D0453840

ALSO BY MORTIMER J. ADLER

# Art,
# the Arts,
# and
# the Great Ideas

## MORTIMER J. ADLER

A TOUCHSTONE BOOK
Published by Simon & Schuster
NEW YORK    LONDON    TORONTO
SYDNEY    TOKYO    SINGAPORE

TOUCHSTONE
Rockefeller Center
1230 Avenue of the Americas
New York, NY 10020

First Touchstone Edition 1995

TOUCHSTONE and colophon are registered trademarks
of Simon & Schuster Inc.

Designed by Jack Meserole

Manufactured in the United States of America

10      9      8      7      6      5      4      3      2      1

Library of Congress Cataloging-in-Publication Data

Adler, Mortimer Jerome, 1902–
    Art, the arts, and the great ideas/Mortimer J. Adler.
        p.      cm.
    Includes index.
    1. Arts.      I. Title.
NX65.A26      1994                                    93–40404
700—dc20                                                  CIP

ISBN 0-02-500243-0
      0-684-80420-4 (Pbk)

# CONTENTS

# PROLOGUE

# *Why This Book*

The title of this book—*Art, the Arts, and the Great Ideas*—calls for an explanation. Readers familiar with my writings about the great ideas may wonder what I am doing writing a book about art and the arts. How did I come to write it?

The explanation is, in part, autobiographical. When in 1982, I published *The Paideia Proposal*, I used language generally current in the educational establishment and in the catalogues of our colleges and universities. Doing that led me to speak of "books and other works of art" and also to use the phrase "literature and the fine arts," which on the face of it implies that literature (epic, dramatic, lyrical poetry) and musical compositions are not works of fine art. The term "fine art" as used then could refer only to works of visual art that adorn institutions called museums of art.

In *The Paideia Proposal*, I outlined the ideal curriculum of basic schooling (kindergarten through twelfth grade) in a three-column diagram that is reproduced in the Appendix attached to this Prologue.

It set forth three kinds of teaching and learning (from left to right): the didactic teaching of subject-matter, the coaching of skills, and the Socratic conduct of seminars concerning ideas and issues and involving books to be read and other works of art to be studied for seminar discussions of them.

In the subsequent years in which we worked to promote the Paideia reform of liberal education at the level of basic schooling there was never a question about the inclusion in the curriculum of instruction in music and in the visual arts. But after many unsuccessful attempts to conduct seminars in which musical compositions and paintings or statues were treated like books as a way to get students to discuss basic ideas and issues, the Paideia Council, in 1990, came to two conclusions that radically changed the original and revised three-column diagram (see Appendix attached to this Prologue).

One was the negative conclusion that music, painting, and modelling did not belong in Column Three at all. They appeared to make no contribution to the discussion of basic ideas and issues. It seemed that books, and only books, served that purpose. This is not to say that music, painting, and modelling cannot be discussed in other terms, such as their aesthetic excellence or the excellence of their workmanship.

The other conclusion was positive. It held that the curricular inclusion of music and visual art belongs in Column Two, where students are coached in the skilled performance of these arts and also coached in listening to music and in viewing paintings, in the same way they

are coached in the skills of the liberal arts, such as reading, writing, and speaking.

In 1990 at a meeting of the Paideia Council, I presented a paper entitled "Paideia and the Arts" that brought me to the writing of this book. Its central question is a difficult one. When musical compositions, paintings, ballets, and so on are not associated with words in any way, do they have anything at all to say about the great ideas? If so, what do they say? It is clear that they are to be enjoyed for their beauty or intrinsic excellence, but in addition, should they be discussed in terms of their relevance to the great ideas?

I am aware that most practitioners of the arts mentioned, as well as most of their critical exponents and members of the general public that enjoy them, will be interested in trying to answer these questions.

I am also aware that there is no point in trying to answer them until all the current confusions and ambiguities to be found in our use of words in speaking about art and the arts are removed. "Art" is one of the most misused words in the English language.

These confusions and ambiguities must first be clarified by knowledge of the relevant history of the terms as they were used from the Greeks until recent centuries. We will find that the prevailing confusions about the words employed and also their misuse have occurred very recently, mainly in the nineteenth century and the present day.

I am, therefore, asking readers to be patiently attentive to the opening chapters of this book where we shall

be dealing with important points in the philosophy of art and in the philosophy of language. The general misuse of the term "idea" is another stumbling block that must be removed by reminding readers of certain basic insights in philosophical psychology. Only after these and other preparatory steps are taken can we come finally to clear answers to this book's central questions, to the explanation of their meaning, and to the argument that supports the answers to which we are led.

# APPENDIX

## THE PAIDEIA CURRICULAR FRAMEWORK*
[Original Diagram]

| | COLUMN ONE | COLUMN TWO | COLUMN THREE |
|---|---|---|---|
| *Goals* | ACQUISITION OF ORGANIZED KNOWLEDGE | DEVELOPMENT OF INTELLECTUAL SKILLS—SKILLS OF LEARNING | ENLARGED UNDERSTANDING OF IDEAS AND VALUES |
| | by means of | by means of | by means of |
| *Means* | DIDACTIC INSTRUCTION LECTURES AND RESPONSES TEXTBOOKS AND OTHER AIDS | COACHING, EXERCISES, AND SUPERVISED PRACTICE | MAIEUTIC OR SOCRATIC QUESTIONING AND ACTIVE PARTICIPATION |
| | in three areas of subject-matter | in the operations of | in the |
| *Areas Operations and Activities* | LANGUAGE, LITERATURE, AND THE FINE ARTS MATHEMATICS AND NATURAL SCIENCE HISTORY, GEOGRAPHY, AND SOCIAL STUDIES | READING, WRITING, SPEAKING, LISTENING CALCULATING, PROBLEM-SOLVING OBSERVING, MEASURING, ESTIMATING EXERCISING CRITICAL JUDGMENT | DISCUSSION OF BOOKS (NOT TEXTBOOKS) AND OTHER WORKS OF ART AND INVOLVEMENT IN ARTISTIC ACTIVITIES E.G., MUSIC, DRAMA, VISUAL ARTS |

The three columns do not correspond to separate courses, nor is one kind of teaching and learning necessarily confined to any one class.

*Adler, *The Paideia Proposal* (New York: Macmillan, 1982), p. 23; *Paideia Problems and Possibilities* (New York: Macmillan, 1983), p. 18; *The Paideia Program* (New York: Macmillan, 1984), p. 8. See also *A Second Look in the Rearview Mirror* (New York: Macmillan, 1992), pp. 105–113.

# THE THREE KINDS OF TEACHING AND LEARNING IN A PAIDEIA SCHOOL*
## [Revised Diagram]

| COLUMN ONE | COLUMN TWO | COLUMN THREE |
|---|---|---|
| ACQUISITION OF ORGANIZED KNOWLEDGE | DEVELOPMENT OF SKILLS | ENLARGED UNDERSTANDING OF IDEAS AND ISSUES |
| by means of | by means of | by means of |
| DIDACTIC INSTRUCTION TEXTBOOKS AND OTHER AIDS | COACHING WITH SUPERVISED PRACTICE | SOCRATIC QUESTIONING IN SEMINAR DISCUSSIONS |
| in these areas of subject-matter | in the operations of | of |
| LANGUAGE AND LITERATURE MATHEMATICS NATURAL SCIENCE HISTORY GEOGRAPHY | READING, WRITING, SPEAKING, LISTENING, CALCULATING, PROBLEM SOLVING, OBSERVING, MEASURING, ESTIMATING EXERCISING CRITICAL JUDGMENT PERFORMING IN THE FINE ARTS | IMAGINATIVE AND EXPOSITORY LITERATURE, WORKS OF VISUAL AND MUSICAL ART, ETC. |

*The Paideia Bulletin: News and Ideas for the Paideia Network* (Chicago, Institute for Philosophical Research), September/October 1990, Volume VI, Number 1; *A Second Look in the Rearview Mirror,* p. 110.

# CHAPTER 1

❖

# *The Current Prevalent Confusions*

1

We are engaged in a philosophical discussion of art, the arts, and the great ideas. For the most part, philosophy has no technical vocabulary of its own, so it must use the words employed in everyday speech, but it must use them with a precision and clarity not found there.

All of the words we must use are generally misused or used with imprecision and with many equivocations. This applies not only to such words as "art," but also to the word "ideas" and to such words as "meaning" or "significance." It even becomes necessary to explain how we are using the word "great" when we refer to the great books and the great ideas. But the two most troublesome words are the words "art" itself and "arts," for the latter calls for a classification of the arts and a

specification of what is meant when the word "literature" is used in connection with that classification.

The words I have called attention to were not always used in the way they are currently in popular speech and in academic discourse. Their usage in antiquity and the Middle Ages was remarkably different. Most of the changes that have occurred, which call for clarification, are of fairly recent origin. For example, the introduction of the phrase "fine arts" (or of their French and German equivalents, *beaux arts* and *schöne Kunst*) is a distinctly modern innovation.

Before I attempt the clarification of all these troublesome words and phrases, and call attention to how these words were once used, I think it may be helpful to note some of the anomalies that occur in their current prevalent usage.

It is unreasonable to demand that people change the way they have been accustomed to using words. Even though I think there is a much better way of using the words in question, I have neither the hope nor a wish to persuade others to change the way in which they have become habituated in their use of words, or by fiat to abolish usages that have long been established by custom.

Nevertheless, I think it is both possible and reasonable to hope that some light will dawn upon those whose atttention has been called to the confusions and misconceptions that are involved in current verbal usage. It may even be useful to make people aware that their use of words involves them in contradictions.

2

The word "art" is now generally used for the paintings that hang on the walls of institutions called museums of art or for the pieces of sculpture that stand on pedestals there. If that were the only or proper meaning of "art," then those who compose pieces of music or perform musically for audiences in concert halls should not be called artists, nor should that name be applied to poets, novelists, dramatists, actors, choreographers, ballet dancers, architects, or other practitioners of the "arts."

If the word "artist" is applied to human beings, should we not understand that artists are those men and women among us who possess this or that art? Is not the art they possess the power to produce this or that object, this or that performance? Is it, therefore, not reasonable to use the word "art" for the skill that makes a human being an "artist," and to use the phrase "work of art" (in French, *objet d'art*) for the product of an artist's productive activity, which can also be called an artistic activity? But not without self-contradiction— if we continue to think that what adorns museums of art and makes the name of such institutions intelligible to us—is the misuse of the word "art" exclusively for paintings and statues.

Let us next consider the phrase "literature, music, and the fine arts." Does it mean that literary and musical compositions are not works of art, or just that they are not works of fine art? How does the phrase "the

arts" come to mean exclusively the visual arts, or even more narrowly visual works of art produced by painters and sculptors, objects hung on walls and stood on pedestals, objects bought and sold in art galleries?

What about the word "literature"? Is anything produced in letters or with words literature? Does literature include all books? That certainly is one usage of the word. Anyone doing academic research compiles a bibliography that he or she regards as the literature of the subject under investigation. But literature has another academic meaning. College catalogues, in addition to listing departments of music and of fine arts (exclusively signifying the visual fine arts), describe English departments as those that give courses in English or in comparative literature. By this is meant *only some* of the books written in English or in other languages, not works of history, science, philosophy, and theology, only books of so-called imaginative literature—books that contain epic, dramatic, or lyric poetry; novels, short stories, and plays.

The confusion is further confounded by the current usage attached to the word "idea" in connection with the reading and study of books and of other works of art. Here the word "other" means paintings and musical compositions.

I shall deal with that troublesome word "idea" later. It is used equivocally in many senses and needs clarification as much as does the word "arts." Also to be treated later are the words "meaning" and "significance."

# CHAPTER 2

❧

# *The Relevant Clarifying History*

1

Throughout the dialogues of Plato and the treatises of Aristotle, the word "art" is used as frequently as "science," and more frequently than the words "philosophy" and "history." Science and art are for the Greeks the two fundamental forms of knowing—the former, knowing that, what, why, and wherefore; the latter, knowing how. Wherever we today, in popular speech, would say that a person possessed the know-how for getting something made or effected, they spoke of the art he possessed.

The Greeks never used the word "art" in an honorific sense or as a term of praise to characterize a work that has a high degree of excellence. They did not make the distinction that we do between arts and crafts, reserving the latter term for the skill of the artisan or workman, and using the word "art" only for skills of

production and performance regarded as having great worth or dignity.

However, as we shall see presently, the Greeks did distinguish between the liberal and the servile arts, and thought of the former as higher and the latter as lower. The practice of the servile arts was for the most part found in the work of slaves and artisans, whereas the liberal arts were to be found only among free men.

To list all the things that are deemed to be arts in the writings of Plato and Aristotle would be a very extensive inventory. A brief sampling of that list would contain the art of the cobbler, the builder, the ship-wright, the pilot, the helmsman, the general, the equestrian, the grammarian, the rhetorician, the soph-ist, the physician, the carpenter, the fisherman, the hunter, the poet, the flute-player, the surveyor, and so on.

2

The list of things that the Greeks called science, such as physics, mathematics, and metaphysics or theology, would constitute a much shorter inventory, though they recognized that certain arts, such as medicine, were based on a substantial amount of scientific knowledge for which they did not have a separate name, such as biology. For them, the word "medicine" named both an art and a science, and in this we still follow them. For the Greeks, the cultural innovation that occurred with the introduction of art rather than the coming to

be of science separated them from other ancient peoples. Homer, in distinguishing the Greeks from the barbarians, refers to the former as the "horse-taming Achaeans."

For our present purposes, the crucial texts are in the works of Aristotle, especially in the *Ethics* and the *Poetics*. In Book VI of the *Ethics*, dealing with the intellectual virtues, Aristotle names five, dividing them into two groups, the three that are concerned with knowing for the sake of knowing (usually called the speculative virtues) and the two concerned with knowing for the sake of action (usually called the practical virtues).

The speculative intellectual virtues are *nous* (understanding or insight), *epistēmē* (the kind of knowledge that is called in Latin *scientia*), and *sophia* (speculative wisdom, sometimes called philosophical wisdom).

The two practical intellectual virtues are differentiated by the two spheres of action—*praxsis*, or doing, moral or political conduct, on the one hand; and *poiesis*, or making something, producing, or performing, on the other. In the sphere of *praxsis*, the intellectual virtue is *phronesis* (prudence or practical wisdom); in the sphere of *poiesis*, the intellectual virtue is *techné* (art, technique, skill, or know-how).

### 3

Within the sphere of *poiesis* (making or performing), two distinctions are introduced, one by Plato, the other by Aristotle. When in the dialogues, Plato deals with

the art of the farmer, the healer, or the teacher, he differentiates between these three arts and all the other arts. He points out that in these three arts, the artist *cooperates* with nature to produce an effect that the powers inherent in nature are able to make without the help or intervention of a human artist.

The fruits and grains of the field grow naturally; the farmer merely helps them to develop with greater regularity by working with the natural processes of growth. So, too, the body heals itself without the help of a physician, and the mind acquires knowledge without the help of the teacher. That is why Socrates, when asked about his method of teaching, replies by saying that he cooperates with nature as the midwife cooperates with nature when she helps the mother to get through the pangs and pains of giving birth to offspring.

All the other arts, according to Plato, are operative rather than cooperative. They operate on natural materials, transforming them to produce the man-made things or artifacts that would not come into existence at all without the intervention of artists. This is not true of foodstuffs, health, and knowledge. These are not artificial or man-made effects, though man's cooperative art may be of service in their coming to be. Aquinas later makes much of this distinction between the three cooperative arts and all the other arts, especially in his treatise on teaching.

The distinction to be found in the writings of Aristotle, but not Plato, is that between the liberal and the servile arts. To understand this distinction rightly, one

must not be misled by the word "servile" into thinking that the servile arts were practiced *only* by slaves. The art of the farmer and the physician, of the builder of temples and the maker of statues, is servile in the same sense that the art of the cobbler, the cook, and the shipwright is servile.

In all these instances of either cooperative or productive art, artists work with physical materials. The teacher, as contrasted with the farmer and the physician, is a liberal artist because, in Aristotle's view, the teacher works with the intellect, which is for him or her an immaterial faculty. So, too, the arts of the grammarian, the rhetorician, the logician, or dialectician, the art of the poet and of the musician are liberal because, according to Aristotle, the artist works with symbols rather than with physical materials.

We may be tempted to dismiss this distinction as one whose significance is entirely conditioned and colored by the fact that Aristotle lived in a society based on the institution of chattel slavery. That would be a mistake, for the distinction has great significance quite apart from that institution and in our consideration of the arts today.

The difference between the arts that produce their work in symbols rather than by transforming physical materials has ontological, not social, significance. It signifies the mode of being or existence of the work of art, not the social status of the person who produced it. A work of art that consists of transformed matter can exist only at one place or locality in the cosmos. It has a

unique or singular physical existence. If, by chance or intention, it is destroyed, it no longer exists anywhere.

In sharp contrast, consider a story told in words, a composition written out in musical notations, a logical argument, a mathematical demonstration, a rhetorical appeal, all symbolically expressed. These works of art do not have any singular locality whatsoever.

There were many different storytellers at many different places who passed on Homer's *Iliad* and *Odyssey* from generation to generation. Many of the writings of Aeschylus, Sophocles, and Euripides have been physically destroyed, but their extant writings can be read anywhere on earth. They exist in as many minds as there are readers whose intellectual imaginations are fed by the verbal symbols used by the dramatists in the writing of their tragedies.

What has just been said about told stories or written ones holds true for all the other arts that use symbols rather than physical matter to produce or make something. The maker of flutes and the flute-player are servile artists, the one making a metallic instrument that exists at a singular place, the other performing on that instrument at one or another particular time; but the composer of music for the flute, who writes its musical notations, is a liberal artist because that score can be reproduced indefinitely, can exist at any time and place, and can be heard imaginatively, by the inner, not outer ear, by anyone who can read music.

Were it not for the fact that the arts of which Plato writes in the *Republic*, where he deals with the edu-

cation of the guardians, became famous in the Middle Ages as the seven *liberal* arts (the arts of the trivium and the quadrivium), we could avoid using the words "liberal" and "servile." The latter word is so repugnant to contemporary ears that we find it more comfortable to state this ancient division of the arts in other terms.

## 4

The significant differentiation is between the material and the immaterial, or between (a) the arts whose products must be sensibly apprehended at a given time and place and (b) the arts whose products can be apprehended anywhere on earth and at any time because they are apprehended by the intellectual imagination.

For our present purposes, we need not consider here the many points that Aristotle makes in his *Physics* and *Metaphysics* about the relationship between art and nature, between the causal process in natural change, especially generation, and the causal process in the production of artificial or man-made effects. But we must spend a moment more on certain basic points in Aristotle's *Poetics* in which he treats the art of poetry.

Though the Greek word *poiesis* signifies any making or producing, the derivative English word "poetry" signifies only one kind of making—making in the special set of symbols that constitute the language of everyday speech. The musician and the mathematician use the symbols of very special languages. We shall subsequently consider whether there is also a special set of

symbols, a special language, used by the painter and the sculptor, but in advance we already know that that language is quite different from the language of music and poetry.

The *Poetics* deals with epic and dramatic narrative. It has little to say about songs or lyrics. It is not at all concerned with the distinction between prose and verse. A historical narrative can be written in verse, and a poetical narrative can be written in prose, as in modern times novels and plays are for the most part.

For our present purposes, we must pay attention to Aristotle's theory of art as imitative of nature and to his distinction between poetical and historical narratives. Poetical narratives, epics or dramas, novels or plays have a special object of imitation, which is human action, not action at a moment, but action in the course of time. Poetic storytelling presents to our imagination something that resembles the human actions with which we are directly acquainted through experience, or that we have learned about by reading historical or biographical narratives. We will consider later whether musical compositions and pictorial paintings have human actions as their object of imitation.

What, in Aristotle's view, is the essential difference between poetical and historical narratives? He tells us in one well-known passage that poetical narratives are more philosophical or more scientific than historical ones. The latter deal only with singularities. The truths known by science and philosophy are universal. The truths recorded in written histories are all particular or

singular. In what sense does poetry stand on a middle ground between the singularities of history, on the one hand, and the generalities, or universals, of science and philosophy on the other?

Aristotle's answer to this question is in terms of the distinction he makes between poetical and logical truths. The singular truths of history and the universal truths of science and philosophy are all truths about actualities. That truth consists, he tells us in the fourth book of *Metaphysics*, in the conformity of the statements asserted by historians, scientists, and philosophers with an independent reality that exists. Logical truth is defined as the correspondence between the judgments made by the mind and the facts that exist outside the mind and are independent of it.

In contrast, poetical narratives have a quite different kind of truth, one that is based not on actual realities but on the realm of possibilities. If the story that a novel or play tells us about human actions has the ring of possibility or probability—if, in short, it has verisimilitude—it has, in Aristotle's view, poetical truth.

A poetically true story is a likely story. Many of the stories told in histories that are true are often much less likely than the stories the poets tell us. Though some of the events or happenings recorded in history are often highly improbable (but never impossible), works of history can be true about what actually did happen.

The distinction between (a) the kind of truth that is in poetry, or the truth of other artistically contrived

narratives (if musical compositions and pictorial paintings have narrative content) and (b) the logical truth to be found in history, science, and philosophy is of the greatest importance. It is concerned with the problem of the crucial difference between (a) books (historical, scientific, and philosophical) as material to be discussed by the Socratic method of questioning and (b) poetical narratives and such narrative content as can be found in musical compositions and in pictorial paintings.

The point that makes the distinction between poetical and logical (or factual) truth so important is simply this. Logical truth is exclusionary. If a statement is logically true, any statement that is incompatible or inconsistent with it must be factually false. Poetical truth is not exclusionary. A narrative that has poetical truth does not exclude other narratives, which tell quite different stories, from also being poetically true.

The realm of the possible is hospitable to a wide variety of different, even contrary, possibilities. All these differing possibilities are *compossible*—things that *can coexist*. The realm of the actual is the realm of the incompossible—things that *cannot coexist*.

One example of compossibility, or of the nonexclusionary character of differing poetical truths, may help to make this point clear. Among the Greek tragedies, there were three stories about Electra, Orestes, Clytemnestra, and Agamemnon—one by Aeschylus, one by Sophocles, and one by Euripides. Among the Greek tragedies, most of which have been lost, there probably were many Antigone stories, many Oedipus stories,

many Medea stories, and so on. One of these does not replace all the others as being the one true story, requiring us to reject the others as false; whereas in science one hypothesis replaces all competing hypotheses when one is found by experiment to be true and all the others are, therefore, excluded by it.

# CHAPTER 3

# *The Classification of the Arts*

1

In the classification of the arts, the significant modern innovation, as recent as the eighteenth or nineteenth century, is the distinction now generally made between the fine and the useful arts. This cuts across all other distinctions made in earlier centuries, for whether an art is liberal or servile, cooperative or operative, narrative or non-narrative, the product of the artist's work is either something to be used as a means to an ulterior end, as chairs, spoons, boats, and eyeglasses are; or it is something to be enjoyed for its own sake, just for the pleasure it gives the beholder.

The English phrase "fine art" is strictly equivalent in its denotative significance to the French *beaux arts* and the German *schöne Kunst*. This tells us at once that the adjective "fine" is not to be understood as the positive degree of that adjective, where the comparative and superlative degrees are "finer" and "finest." The word "fine" when it is used in the phrase "fine art" is

not a grading term, as it is when one says "that's a fine piece of cloth" or "that's a fine orange squeezer." What, then, is the explanation of its meaning when, as seems to be the case, it functions as a synonym for the word *beaux* and the word *schöne*?

The explanation, I think, is that in this very special usage the etymological derivation of the English word "fine" is from the Latin word *finis*, which means "end." If something is appreciated as being beautiful, it is treated as an end, something to be enjoyed for itself, and not used as a means to some further objective. Anything seen as beautiful is regarded as an end in itself, not as a means to something beyond itself. It certainly makes good sense to say that all works of art that are enjoyed for their beauty have the finality of ends in themselves.

## 2

One further clarification is necessary. The intention of the artist and the intention of the recipient of his or her work have no relevance at all to the distinction between the liberal and the servile arts, or between the cooperative and purely operative arts. These distinctions depend entirely upon the manner and the means of the artist at work. The cabinetmaker who fashioned a Sheraton chair or table may have intended it for use as furniture, but when we put these antiques in a museum, place them on elevated platforms, and surround them with a red cord and a sign that says "Do

not touch," our intention is different from that of their maker. We are treating them as beautiful objects to be enjoyed simply by beholding, not using them.

So, too, a painter of pictures may have the intention of producing something beautiful, something to please the eye when it is viewed. But the buyer of the picture may use it to make money on its resale or to hang over a stained spot on the wall. A piece of music intended by its composer to be enjoyed may be used by a mother to soothe a crying child to sleep.

Clearly, the same point holds for the products of architecture, but with this difference: the architect has both the use of the building in mind and its aesthetic excellence as something to be viewed from different angles. The great architects try to wed form and function harmoniously, so that the beauty of the building does not detract from its usefulness, and conversely, that its utility does not impair its beauty in any way.

Since, from this point on, we shall be concerned only with the fine arts and with their most significant subdivisions, it is important to say that the intentions of the artist and of the recipient of his or her work have no more relevance for us. In our further consideration of the fine arts or the arts of the beautiful, we need not be concerned to take one side or the other on the issue about beauty—whether it is entirely subjective (entirely in the eye of the beholder) or is objective as well as subjective (the work of art having some degree of intrinsic excellence as well as being pleasing to the viewer or the listener).

## 3

Concerning beauty, permit me a brief digression. Widely remembered and quoted is that famous couplet from the sonnet "Ode on a Grecian Urn" by John Keats: " 'Beauty is truth, truth beauty,'—that is all/Ye know on earth, and all ye need to know." If the word "is" in that statement means "is identical with" or "is the same as," the statement is, of course, flatly false. It cannot, therefore, be knowledge that we need.

If we interpret the "is" to mean "wherever one finds beauty, there one also finds truth," the statement is still false, for there are many beautiful objects in which there is no truth at all. They may have sensible beauty or intelligible beauty but neither poetical nor logical truth. The statement by Keats has some logical or factual truth only if it is interpreted, not as an unexceptional generalization, but rather as a statement that holds for a relatively small number of exceptional instances in which the work produced by an artist has logical or poetical truth as well as sensible or intelligible beauty. A pictorial painting that has historical significance may have beauty but little or no factual truth, whereas a journalistic photograph may have factual truth but little or no beauty.

## 4

In terms of this very special, ontological conception of truth, there may be an analogous meaning of truth

for the creative artist who is, like God, a creator. But the artist is a creator only in an analogical sense of the word "creator," not a univocal sense of that word. God creates *ex nihilo*, while on the plane of human creation (more properly called making, not creation), the artist makes or produces a work of art, not *ex nihilo*, but out of natural or artificial materials. God, in other words, is not an artist. Having the intellectual virtue of art is a human, not a divine attribute.

When the work produced by the human artist conforms to the creative idea in his or her mind, then it can be said to have ontological truth. If it is the intention of the artist to produce a work of beauty, the resultant beauty may be concurrent with its ontological truth. This is true only if there is objective beauty, an excellence intrinsic to the work, not just beauty in the eye of the beholder. With this clarified, we can leave the point behind as we go on with the consideration of the fine arts.

## 5

The seminar discussions of works of fine art—especially paintings, sculptures, and musical compositions—are one of our concerns in this essay. With respect to such works (those that have, in any degree, sensible beauty), we are, therefore, interested only in their possession of logical truth (in relation to the reality of actual fact) or of poetical truth (in relation to the realm of the possible).

As Horace points out in his treatise on the art of poetry, poetry performs two functions—instruction and delight. The delight derives from the beauty of the work; the instruction, from its logical or poetical truth. Whether other works of fine art, paintings and musical compositions, are like poetry in this respect is a question to which we must try to find the answer. To prepare for the task of doing so, we must make the distinctions that are involved in relevant subdivisions among works of fine art. There are four subdivisions to consider.

## 6

(a) Works of fine art are *either* spatially located works *or* temporally sequential works. Paintings, sculptures, buildings, and other architectural monuments are works of the first sort; narrative poetry, musical compositions, ballets, and operas are works of the second sort.

(b) Works of fine art are *either* explicit narratives, like novels and plays, *or* they have implicit narrative content, like historical and religious paintings; but in contradistinction to these works, there are many works of fine art that have no explicit narrative significance (e.g., sculptures, buildings and other architectural monuments, all nonpictorial paintings, and all nonprogrammatic music).

Before we leave this second point, it may be of some interest to remind readers of the discussion

between two German writers about the arts, Gotthold Lessing and Johann Winckelmann, who asked whether a statue, frozen in time, could by implication tell a story by means of representing one moment in it and leaving to the imagination of the viewer the preceding and succeeding moment required for the apprehension of the story as a whole. For the purpose of this inquiry they focused on a famous statue, that of the Laocoön—the father and his three sons caught in the coils of a monstrous serpent. As we have seen, it is clear that the statue has implicit narrative significance of the same kind that implicitly narrative paintings have.

(c) Works of fine art are *either* verbal compositions, using the words of everyday speech (and, in the case of imaginative literature, they also usually contain statements that express the thought of the characters in a novel or play as well as, in the novels, the thought of its author), *or* they are nonverbal productions, using the vocabulary of the special language of musical notations or the vocabularly of the special language of purely visual elements, such as lines and shapes, colors, and shadows. In the works of nonverbal fine arts, we can find no statements that express the thought of the artist—at least, no statements of thought that have the syntactical and lexical meaning of statements in the language of everyday speech.

(d) Finally, works of fine art are *either* elementary *or* composite; in other words, they are *either* produced

entirely in a single language (that of ordinary speech, the language of musical notation, and the language of visual symbols) *or* they are hybrids, combining the symbols of two languages, that of everyday speech with the symbols of musical notation or with the symbols of visual presentations.

## 7

I am going to use the word "literary" to signify the verbal component that is combined with the nonverbal elements of musical composition and of visual composition. The literary aspect of music, for example, is to be found in certain kinds of program notes. The literary aspect of narrative pictorial paintings is to be found in the titles of the pictures that identify their historical or religious significance.

It is only in hybrid works of art that the literary aspect of them is actually present in more than the title, as, for example, in the librettos of operas and classical ballets, and in the words of lyric poetry set to music in songs.

In the field of the visual arts, paintings divide into those that are pictorial and those that are nonpictorial (so-called abstract, or nonrepresentational, paintings). The pictorial paintings are further subdivided into landscapes, seascapes, still-lifes, and portraitures, on the one hand, and historical and religious narrative paintings, on the other. All of them can have poetical, but not logical, truth. The large class of nonpictorial paint-

ings that have come into existence in this century cannot have any narrative significance, nor any modicum of poetical truth.

In the field of musical compositions, most of the great chamber music, most of the sonatas, and many of the symphonies and symphonic suites have little or no literary aspect, except what they derive from a verbal title and a few program notes. For the most part, they are identified only by opus number, which, in the absence of a literary aspect, is quite appropriate. They should remain untitled.

This can be summed up by saying that there is little poetical truth, if any at all, in the great works of music, as well as little narrative significance, if any at all. The exceptions to this generalization arise from hybrid works of music—operas and classical ballets—which do have a literary aspect in the verbally written librettos that accompany them.

## 8

Finally, I speak now of the two kinds of goodness—beauty and truth—in a relatively small number of paintings. Learning how to appreciate their aesthetic excellence is one cultivation of the mind that a general, liberal schooling should initiate. Learning how to understand the poetical or logical truth that is in them is a distinct and different cultivation of the mind that a general, liberal schooling should also initiate.

In any case, the kind of tutoring or tutorial that cul-

tivates the habit of aesthetic appreciation in the case of both painting and music applies to all the great works in this field. Acquiring aesthetic appreciation for lyric poetry also belongs here.

Only the kind of imaginative literature that consists of the various modes of narration requires the kind of learning that lies at the heart of seminars because it involves dealing with logical as well as poetical truth.

# CHAPTER 4

# *Transition: From History to Philosophy*

1

I am eager to help readers know where they have been and where they are going in this elaborate sequence of preparatory steps needed to support the argument for the central thesis of this book.

The preceding chapters have been mainly historical, dealing with present and past views about art and the arts. They contain some philosophical insights relevant to the classification of the arts.

The chapters to follow are primarily philosophical. They are concerned with the philosophy of language, explaining how the sensible but meaningless notations we use get meaning and become meaningful as words. We will consider the difference between words as signs and nonverbal symbols, the difference between designative signs and signs that function as signals, and

how this difference affects our use of nonverbal symbols as well as our use of words.

In our consideration of language, we must differentiate between common human languages, such as English, French, and German, and special languages, such as the language that uses the symbols of mathematics or the language that uses the symbols employed in the writing of musical scores. In this connection, we must consider whether these special languages function in the same way that common languages do as means of communication; or are they merely means of expression, stating what is otherwise incommunicable?

Our excursion into philosophy will take us into psychological questions about the contents of the mind when it is engaged in acts of thought, and also about the difference between the sensitive acts of the mind (its perceptions, imaginations, memories) and its intellectual acts (its conceptions and conceptual constructions, its judgments, and its rational processes).

In the chapters to follow, I will be making points that I have expounded and explained in earlier books: in chapters on sense and intellect and on words and meaning in *Ten Philosophical Mistakes* (1985); in the opening chapters of *Intellect: Mind Over Matter* (1990) and in the Foreword I wrote for *The Great Ideas: A Lexicon of Western Thought* (1992).

In writing that Foreword I said that it was intended "especially for readers who have never seen *The Syntopicon*." Some understanding of *The Syntopicon* is

necessary for those who may wonder how works of imaginative literature (which are certainly among works of fine art along with musical compositions, paintings, ballets, etc.) can be relevant to topics under the 102 Great Ideas that are chapters in *The Syntopicon*, whereas nonverbal works of fine art necessarily fail. Chapter 8, "With and Without Words," is directly on that point.

## 2

I think I know some of the questions that may have occurred to readers about the matters to be treated in subsequent chapters. They are questions that would not have been raised if points in the philosophical clarification to follow had been understood.

For example, it may be asked whether it is possible to have an idea that cannot be put into words. What is the difference between ideas that can be verbalized and those that cannot be?

Without understanding the radical difference between perceptual and conceptual thought, it may be asked whether chimpanzees, observed to be solving problems, are engaged in acts of thought in which they have ideas in mind.

It is often said scenes of violence in movies put ideas into the heads of children. If so, does that imply that pictures, even when unaccompanied by words, convey ideas? And if so, can the same be said of paintings and other works of visual art?

Consider all the Renaissance paintings of Madonna and Child. Do all these paintings express the idea of motherly love? The same idea of it, or different ideas of it? If different, can it be said that we can find disagreements among painters who appear to be dealing with the same subject, just as we can find disagreements among authors who are writing about love?

None of these questions would ever be asked if equivocation in the use of the word "idea" were avoided; and beyond that, if an understanding of the relevant points in philosophical psychology had prevented them from being raised.

# CHAPTER 5

# *Language, Mind, and Meaning*

1

Like most words in everyday speech, especially like the words we are using in this book, the word "language" is used equivocally—sometimes for a means of communication and sometimes as a means of expression for what is incommunicable; other times for sounds, gestures, or grimaces that animals in the wild employ to elicit responses from other animals; and sometimes for the speech of human beings, which uses words syntactically organized as different parts of speech to form sentences.

As the word implies, communication can occur only about what is common to two or more persons engaged in conversation. If they are considering the kinds of love, they are communicating only if the word "love" is being used by all of them with some common meaning. Otherwise, if that word is used by them as equiv-

ocally as the word "pen" is when it refers, on the one hand, to an enclosure for pigs and, on the other hand, to a writing instrument, they have nothing in common to talk about and are not communicating.

I am not here concerned with the laboratory experiments that train chimpanzees or bottle-nosed dolphins to acquire a small vocabulary of sounds that appear to function like words, even if their meanings are not acquired in the way that children acquire a much larger vocabulary in their early years. My main concern is with human languages, some of which are natural languages, such as English, French, and German, and with the difference between all these natural languages and the artificially contrived languages that human beings use for special purposes.

The difference lies in the fact that anything that can be said in one natural language can be translated into other natural languages, except perhaps for idiomatic expressions that are peculiar to one of these natural languages and have no precise equivalent in another. Take, for example, the special language of mathematics as it has developed in modern times. A page of mathematical symbols is intelligible to mathematicians all over the world. What the page of mathematical symbols communicates can also be rendered with enormous difficulty in English and at much greater length than one page. But it is possible, though there may be no good reason for trying to do it.

I have used the word "symbol" for what functions like a word and, therefore, can be called a sign. There

are two kinds of signs—words, or verbal signs; and symbols, or nonverbal signs. What the plus, minus, and equal symbols $(+, -, =)$ mean in a page of mathematics can also be conveyed by the words "plus," "minus," and "equal." The latter, being words, are signs, not symbols. Although everything that can be said on a page of mathematical symbols can also be said, at much greater length and with difficulty on pages of words, the reverse is not the case. Very little of what can be said in everyday speech or by using verbal signs can be said in the special language of mathematics.

2

Words can be used either as designators or as signals. As designators they name something. Proper names designate unique individuals, common names designate the classes to which things belong, the qualities or attributes they possess, the actions they perform, and so on. For the moment, I am not concerned with articles, prepositions, and other words that help make sentences.

Words are used as signals when they elicit behavior of one kind or another. For example, in a lumber camp a bell can call the lumberjacks to breakfast, or the word "eats" can be shouted from the porch of the dining hall; in the latter case, such words as "eats" or "breakfast" which serve to name meals are used as signals, not designators. Similarly, the word "fire" shouted in the theatre or the ringing of a fire alarm signals an event

that calls for a certain reaction, although, unlike the fire bell, the word "fire" also describes the combustion that campers in the woods try to cause to cook their dinner.

Nonverbal symbols can also be used in the same two ways that words are. For example, in hotels and restaurants, male and female restrooms are designated either by such words as "ladies" and "gentlemen" or by symbolic representations affixed to the doors that serve to designate the sex of the occupants or to signal which one should be used by this gender or that one.

When individuals say that clouds of a certain kind mean rain, or when they say smoke on the horizon means that a fire is occurring there, they are using the word "means" for signaling, not for designating. They have learned from certain natural sequences that have occurred in their experience that if clouds of a certain kind appear in the sky, rain will soon follow. The clouds signal the coming of rain.

The sounds, gestures, and grimaces of animals in the wild are never designators. They do not name things. They function as signals of what other animals in the neighborhood can expect in the way of behavior.

Animals in the wild are not talking to one another. They are not communicating with one another as human beings are when they use words to designate an object that two or more of them are considering and about which they are making contrary statements and arguing for or against what is being asserted or denied.

3

I said earlier that human speech can be used either to communicate or to express what cannot be communicated. An individual's bodily feelings and the subjective states of mind that are idiosyncratic, experienceable by that one individual alone, can be expressed in speech. I can tell you about the toothache I am having, and what I say about it can lead you to imagine what my toothache feels like. But having a toothache and imagining what a toothache feels like are not the same thing.

I also can use words to express my emotions and my sentiments, but when I do so I am telling you something about myself that is, strictly speaking, incommunicable. These emotions or sentiments are mine, not yours. If you were my psychoanalyst, you might wish to rid me of these emotions or sentiments, but unless you question my veracity, you would take my report as a statement of fact. I would be using language to express myself. It is *myself* that I am exposing. This use of language is clearly different from the use of language to communicate, to converse, to agree or disagree, and, if disagreeing, to dispute.

4

In this chapter, we are concerned mainly with the natural language of our everyday speech and with words and their meanings. Before we go on to deal with the

difficult problem of the meaningful and meaningless, it may be useful to recount for readers the basic distinctions we have so far encountered.

The primary distinction is between words or verbal signs and the nonverbal signs for which we have used the word "symbols." Both the verbal signs and symbols are carriers of meaning. In the sphere of verbal signs or words, the other basic distinction is between designative signs (or names) and signals. The same distinction holds in the sphere of symbols: they either designate and name or they function as signals. The symbols that indicate a pawnshop or a barbershop can also function as words do when they name one or another kind of store.

In the next section we shall consider how meaningless notations (which are not words, for there are no meaningless words) become meaningful words. Whence comes their meaning?

To answer that question, a further distinction must be considered—that between formal and instrumental signs. This distinction has been completely ignored in modern linguistics and its theory of meaning. It involves a difficult point in philosophical psychology: the point that the cognitive content of our mind is not that *of* which we are directly or introspectively aware, but rather that *by* which we know or understand everything that is knowable and intelligible.

Our bodily feelings—our pains and aches—we directly experience, but this mental content is not cognitive. We have such feelings, but they are not our

means of knowing or understanding anything. This point will become clearer in the course of the next chapter, when we deal with our mental contents and acts in relation to the objects that are knowable and intelligible.

Finally, we will turn to the special language of musical scores, which is like the special language of mathematical symbols, and ask whether there is any comparable special language in the sphere of the visual arts—paintings and works of sculpture. Then, and only then, are we prepared to explain the 102 Great Ideas, *which are in no sense whatsoever any part of our mental content*.

## 5

I am now going to introduce a new word that we need in order to carry on this discussion of the meaningless and the meaningful. I use the word "notation" to refer to a visible mark or an audible sound that, being sensible, is perceptible by us. Notations are perceptible but totally devoid of meaning. They are, strictly speaking, like nonsense syllables, such as "glup" or "tharp."

When traveling in a foreign country, we hear its citizens talking to one another in a language that we have not yet learned; the words they are using are for us meaningless notations. Only after we have learned the foreign language do these meaningless notations become meaningful words for us. What previously were meaningless notations have gained meaning. How did

they get the meaning they now have to become meaningful words?

One way of answering this question is to consider how very young children acquire a vocabularly of meaningful words that, at first, were only meaningless notations for them. In Chapter 3 of *Ten Philosophical Mistakes* I tried to explain the process by which children acquire a language that has a vocabularly of meaningful words. I cannot improve on what I wrote in 1984, but I can abbreviate the explanation by omitting what is not relevant here. The paragraphs to follow will repeat, without quotation marks, an excerpting that makes the points we should consider here.

When a baby learns to speak and later to read, or when we learn a foreign language, marks and sounds that were at first meaningless become meaningful. A meaningful notation is a word. Notations can be meaningless, but there are no meaningless words.

Another fact with which we are all acquainted is that most words have multiple meanings. One and the same word can have a wide variety of meanings. In addition, in the course of time, a word can lose one meaning and gain another—acquire a new meaning.

A dictionary is the reference book we use when we wish to ascertain the various meanings of a particular word. The great dictionaries often give us the history of that word—the meanings it once had, but no longer; the new meanings it has recently acquired.

This is familiar to all of us. But we seldom stop to ask how that which at first was a meaningless notation

acquired the meaning that turned it into a meaningful word—a unit in the vocabulary of a particular language, something to be found in the dictionary of that language. Where did the meaning or meanings acquired by that meaningless notation come from to turn it into a word?

Looking up the word in the dictionary does not answer that question. What you find there is a set of other words that purport to state its meaning or meanings. If in that set of words there are one or two that you do not know the meanings of, you can, of course, look them up. What you will find again is another set of words that state their meanings, and either you will understand the meanings of all these words or you will have to repeat the process of looking them up. If you knew the meanings of all the words in the dictionary, you would, of course, never resort to using it. But even if you did, the dictionary could not help you to find out how any one of the words it contains acquired meaning in the first place.

Let me be sure this is understood. Consider the person who refers to a dictionary to learn the meaning of the notation that was at first glance a strange "word" or just a notation for him or her and so not yet a word at all. This procedure, while adequate for some notations, cannot be suitable for all. If the person's only approach to or means of learning a foreign language were a dictionary of that language, and one which used that language exclusively, he or she could not learn the meaning of any of its words. Only on the condition that

he or she already knows or can somehow learn the meanings of a certain number of the words without the use of the dictionary, can the dictionary become useful as a way of learning the meanings of still other words in that language.

For a child to get to the point at which he or she can move effectively within the circle of a dictionary, some meaningless notations must have become meaningful words—*and become so without the help of a dictionary*. The dictionary, therefore, cannot be the answer to the question of how meaningless marks or sounds become meaningful words.

This is not to dismiss the usefulness of dictionaries. We often learn the meaning of a word that is new and strange by being told in other words that we understand what that word means. Thus, for example, when a growing child hears the word "kindergarten" for the first time and asks what it means, he or she may be quite satisfied with the answer "It is a place where children go to play with one another and to learn."

If the words in the answer are intelligible to the child, the child is able to add a new word to his or her vocabularly. A notation that was meaningless has become a word by means of a verbal description of the object signified. The answer to the child's question is like a dictionary definition—a verbal description of the object signified by the word in question. Such descriptions can be reinforced by what are called ostensive definitions—pointing to the object or word.

This, however, does not suffice as a solution to the

problem of how meaningless notations become meaningful words for us. It holds for some words, but it cannot hold for all. We learn the meaning of some words in our vocabularies by understanding the verbal descriptions of the objects they signify. But if we tried to apply that solution to all words, we would be going around in an endless circle that would defeat our search for a solution to the problem.

In what other way than by verbal descriptions can meaningless notations acquire meaning and become words? The answer is by direct acquaintance with the object that the meaningless notation is used to signify.

The simplest example of this is to be found in our learning the meaning of proper names. Whether or not we remember what we were taught in grammar school about the distinction between proper and common names, all of us know the difference between "George Washington" and "man" as names. The first names a unique, singular person—a one and only. The second names a distinct kind of living organism, a kind that includes only certain living organisms and excludes others. Words that name unique, singular objects are proper names; words that name kinds or classes of objects are common names.

I chose "George Washington" as an example of a proper name to make the point that we can learn the meaning of some proper names only by verbal descriptions. None of us has ever been or can be introduced to George Washington. We can have no direct ac-

quaintance with him. We know what his proper name means by being told that it signifies the first President of the United States.

The situation is quite different with other proper names—the names of all the persons in our own families or persons we have been introduced to in the course of our experience. The verbal introduction may be as brief as "Let me introduce you to John Smithers." But it accompanies your direct acquaintance with the object named. That is how "John Smithers" becomes for you the proper name of the person to whom you have been introduced.

So far, so good. But how do meaningless notations become significant *common*, as contrasted with *proper*, names by direct acquaintance rather than by means of verbal descriptions? Very much in the same way. The baby is told that the animal in his playroom is a dog or a doggie. This may be repeated a number of times. Soon the baby, pointing at the animal, utters "dog" or "doggie" or something that sounds like that. A significant common name has been added to the baby's vocabularly.

This will have to be confirmed by another step of learning. The baby may, on another occasion, find itself in the presence of another small animal, this time a cat, and call it a doggie. The error of designation must be corrected. Not all small animals are dogs. When the word "cat" has been added to the baby's vocabulary as a common name that signifies an object quite distinct

from dog—both objects with which the baby has been acquainted directly—the two words not only have meaning for the child, but also different meanings.

Have we solved the problem now? Not quite, for in the course of the child's growth, with his or her education in school and college, and with all the learning that is acquired through a wide variety of experiences, his or her vocabularly of common names will be expanded greatly. Those same two objects that, in the nursery, were called cat and dog, he or she will be able to identify by other common names, such as "feline" and "canine," "Persian" and "poodle," "mammal," "quadruped," "vertebrate," "domesticated animal," "pet," "living organism," and so on.

If we say that all of these common names acquired their significance through our direct acquaintance with the objects named, we should be sorely puzzled by the question of how the very same object of acquaintance can produce this extraordinary variety of results. If a meaningless notion gets meaning and becomes a word for us by being imposed on an object with which we are acquainted directly, how can one and the same object with which we are acquainted directly give quite distinct meanings to all the common names we use to refer to it?

The problem is further complicated by the fact that not all of the common names we use refer to objects that we perceive through our senses, such as cats and dogs. Not all signify perceptual objects with which we can have direct acquaintance.

What about such common names as "liberty," "equality," "justice," or "electron," "neutron," "positron," or "inflation," "credit," "tax shelter," or "mind," "spirit," "thought"? None of these is a perceptual object with which we can have direct acquaintance. How in these cases did what must have been at first meaningless notations get meaning and become useful words for us?

Is the answer that here all meanings are acquired by verbal description? We have already seen that answer to be unsatisfactory because it sends us around in an endless circle.

Is the answer that here, too, we have direct acquaintance with the objects named, but acquaintance in ways other than through perception, memory, and imagination that ultimately rests on the use of our senses? If so, what is the nature of that direct acquaintance and what is the character of the objects named, with which we are acquainted by means other than the action of our senses leading to perception, memory, and imagination?

We are now confronted with a problem that modern philosophers have failed to solve because of a number of philosophical mistakes that they have made. One is the mistake of treating our mental content—our perceptions, memories, imaginations, and conceptions or thoughts—as objects of which we are directly aware, or conscious. The other is the mistake of reducing all our cognitive powers to that of our senses and failing to distinguish between the senses and the intellect as

quite distinct, though interdependent, ways of apprehending objects.

Before I turn to a consideration of the modern failure to solve the problem of how meaningless notations become words through acquiring meaning, I must call attention to one further point that should be familiar to all of us when we consider words and meanings. A meaningful word, a notation with significance, is a sign. A sign functions by presenting to the mind for its attention an object other than itself. Thus, when I utter the word "dog," you not only hear the word itself, but hearing the word also serves to bring before your mind the object thus named.

What is common to the name words we have so far considered is that they are themselves objects of which we are perceptually aware as well as instruments that function to bring to mind the objects they signify. Let us, then, call such designators instrumental signs. Their whole being does not consist of signifying. They have perceptible existence in themselves apart from signifying, but they are also instruments for functioning in that way.

Most important is the consideration of the problem we have posed about words in human vocabularies that function as designators. As we shall find, the solution to that problem will involve the discovery of another kind of designative sign, *one the whole existence of which consists of signifying*.

Like other signs, signs of this special kind present to the mind objects other than themselves. But unlike

other signs, they themselves are entities of which we have no awareness whatsoever. *They are thus radically distinct from the kind of signs we have called instrumental signs. Let us call them formal signs.*

The philosophical mistake here consists of the neglect of formal signs in the attempt to explain how meaningless notations get their designative significance and become words in the vocabularies of ordinary human languages.

## 6

In the paragraphs to follow, continuing my excerpting of what I wrote in 1984, I will deal with the difference between instrumental and formal signs. In doing so, I am going to avoid using the word "idea" and replace it with the phrase "cognitive mental content" to refer to the sensitive content of the mind—its sensations, perceptions, memories, and images—and also to its intellectual content, its concepts.

If our mental content is cognitive, it is not *that which* we directly apprehend, but rather that *by which* we apprehend whatever we know or understand by means of our sensitive faculties or by means of our intellect.

The objects to which we give names and to which we refer when we use the words that signify them are the objects that we directly apprehend by cognitive mental content. This, as we shall presently see, holds true just as much for the intelligible objects of concep-

tual thought as it does for the sensible objects of perception, memory, and imagination.

I have thus called attention to the distinction between instrumental and formal signs. Instrumental signs are themselves objects we apprehend, as are the objects that these signs refer to. But a formal sign is never an object we apprehend. Its whole existence, or being, lies in the function it performs as a sign, referring to something we apprehend, something it serves to bring before our minds. It is, as it were, self-effacing in its performance of this function.

The basic truth here is that *our cognitive mental content consists of formal signs*. Another way of saying this is that our cognitive mental contents *are* meanings.

Let me repeat this point: our percepts and concepts do not *have* meaning; they do not *acquire* meaning; they do not *change, gain,* or *lose* meaning. Each of them *is* a meaning, and that is all it is. Mind is the realm in which meanings exist and through which everything else that has meaning acquires meaning.

The referential meanings that some of our words acquire when meaningless notations take on referential significance derive from their being voluntarily imposed on objects with which we have direct acquaintance. Those objects are the objects meant, signified, referred to, intended, brought before our minds, by the cognitive mental content that consists of formal signs.

Our percepts and concepts are the formal signs we never apprehend. They enable us to apprehend all the

objects that we do. Those words that do not acquire meaning by verbal descriptions of the objects named acquire it by our direct acquaintance with objects that our cognitive mental content enables us to apprehend. These are also the objects that formal signs refer to.

Furthermore, because the words we employ have referential meaning as instrumental signs through their association with formal signs, we can use words not only to refer to the objects that we directly apprehend by means of them, but also to arouse cognitive mental content in the minds of others so that they have the same objects before their minds. It is in this way that we communicate with one another about objects that are public in the sense that they are objects apprehended by, and so are common to, two or more individuals.

If our cognitive mental content consists of formal signs that confer meaning on the instrumental signs that are the meaningful words we use to designate the perceptual objects of our sensitive faculties and the intelligible objects of our intellects, then it follows that mind is the realm in which meaning exists.

A world without minds—animal or human—would be totally meaningless. Everything else might be the same, but without the operation of formal signs that *are* meanings nothing would have any significance. Everything else in the world that has meaning gets it from some source other than itself. Only our cognitive mental content *is* meaning and *gives* meaning.

7

We turn now from words or verbal signs that are name words or designators to symbols that are nonverbal signs or designators. The same basic points must be made with respect to them.

For a person who is totally uninstructed in music, a musical score is as unreadable as a book in Greek is to a person who is illiterate in that language. The visible marks on the page of the score are meaningless notations. They become instrumental signs (i.e., perceptible meaningful notations) only after the person has received instruction in music. That instruction with respect to the language of music involves the functioning of formal signs which *are* the meanings that the musical symbols acquire with the development of musical literacy.

What are these meanings? The composer of a musical composition is thinking of the sounds to be played by this or that instrument or the sounds to be heard by another musician who reads the score and hears imaginatively the unperformed piece of music. The composer, who may have been deaf, as Beethoven was, hears the music in his or her mind by imagining it, and uses the musical symbols he or she writes down on the score to direct others who can read the score to hear the sounds that the symbols call for.

The composer's imagination of the unperformed music involves a sequence of formal signs that give meaning to the musical symbols written on the score.

Those musical symbols then function for readers of the score in the same way that words do when they are meaningful notations in the language of everyday speech.

The thinking that the composer does about producing his or her work involves mental content that is not cognitive; it is productive. The result of such thinking is the finished product. If anyone were to ask the composer engaged in writing the score of a composition what he or she had in mind, he or she could answer that question in only one way—that is, by writing out the score. If you were unreasonably impatient and pressed for an answer to your question, the composer might say: "You want to know what I have in mind; then sit down and listen and I will play it for you."

The same answer would be given for other arts, such as painting or imaginative literature. The thinking being done by the productive artist is radically different from thinking that is cognitive. The artist can say what he or she has in mind only by producing the work of art that he or she has in mind.

I have not mentioned that a musical score may contain some verbal language as well as musical symbols. Words may be used to name the tempos of different movements in a symphony. However, for the most part, the score consists of notations that are symbols in the language of music.

The sounds imaginatively heard by musicians with the score in their hands, or the audible sounds heard by audiences in concert halls, may resemble sounds

heard in nature—the sound of thunder, of a waterfall, or of a farmyard. The composer's intention may be to produce music that imitates such sounds, as the *Pastoral* Symphony of Beethoven does. The intended imitation of nature is accomplished by the resemblance, or similarity, between the musical and the natural sounds.

Only some musical compositions are imitative in this way, and the verbal title that the composer attaches to his or her composition informs the audience of this imitative intention. But such compositions are the exception rather than the rule. Most of the great works of music, especially all those that carry an opus number rather than a verbal title, have no referential significance whatsoever—that is, no imitative intention. I shall return to this point in Chapter 8, where we shall be concerned with hybrid works of art that combine the use of words with nonverbal symbols.

# 8

In the field of the visual arts, is there anything like the special language of music? In the case of paintings, is there any sense in which one painter can "read" the work of another painter, as one musician can read the score of another? The answer is negative unless we can find some meaning for the word "read" that is not strictly equivocal—that is, which does not mean what that word means when it is used to refer to the reading of books or musical scores.

Among the titles James McNeill Whistler gave to his

portraits are "Symphony in Grey and Green: The Ocean" and "Arrangement in Grey and Black," which became known to the world as "Whistler's Mother." If there is any special language for paintings, Whistler's use of the names of colors and, perhaps, also of certain shapes or configurations, suggest what such a special language might be like.

In the sphere of all the nonpictorial paintings that have occurred in this century, the use of verbal titles follows Whistler's style. They may be called "Study in Pinks," "White on White," or "An Arrangement of Cubes," and so on.

In the case of narrative or religious paintings, the verbal titles attached to such pictures merely serve to inform the viewer what object is being pictured. Here the visual artist is picturing something that is a representation of some event, landscape, or person. This representative picturing is like the musical composition that imitates by resembling some natural sounds. This is hardly a special language using nonverbal symbols, though the words used in the title point out the referential significance of representative, or pictorial, painting.

# CHAPTER 6

# Mind: Its Contents, Acts, and Objects

1

In the preceding chapter, the circumlocution "cognitive mental contents" avoided use of the word "ideas" because that word has been so flagrantly misused in modern philosophical thought, since Descartes in the seventeenth century and Locke in the eighteenth century. Once or twice in the previous chapter, I indicated the words that should be used in place of ideas to name the mind's contents when the mind is acting cognitively. I shall return to those words in this chapter, but first I wish to give a brief history of the word "idea" in antiquity and the Middle Ages, and then explain its misuse by modern philosophers.

The word is, of course, used in a variety of senses in everyday speech. To ask a person what idea he or she has in mind is like asking what he or she is thinking about. "What's your idea?" is often an inquiry calling

for your plan of action or something else that you might be proposing. "Get that idea out of your head" comes as instruction to change your mind. "What is the idea?" expresses an amorphous inquiry about your mental content; almost anything could be the answer.

In antiquity, it was Plato, not Aristotle, for whom the word "ideas" was a focal term. It occurs everywhere in his dialogues; not so in the treatises of Aristotle, who used the word "form" instead.

Chapter 2 of my book *Six Great Ideas** is entitled "Plato, Right and Wrong." Plato was right in using the word to name the intelligible objects of the mind—the objects of conceptual thought, not the thought itself. His error, which Aristotle corrected, was in thinking that ideas, as intelligible objects, have a superior and immutable reality in the realm of being, as contrasted with the changing sensible objects in the realm of becoming.

In this book, I will use the word "idea" for the *intelligible* objects of the intellect only when it is engaged in thinking for the purpose of understanding. Thus, instead of referring to the idea of truth, I will refer to truth as an intelligible object, as an object of thought when we think conceptually. It would be more cumbersome but more accurate to entitle an essay on the idea of liberty as an essay on liberty as an object of conceptual thought.

Two modern philosophical errors, errors that infect

*Six Great Ideas* (New York: Macmillan, 1981).

our everyday speech, help to explain the misuse of the word "ideas" since the seventeenth century, beginning with Descartes' reference to "clear and distinct ideas" in his *Discourse on Method*. The same error is even more explicitly made by John Locke in the Introduction to his *Essay Concerning Human Understanding*, when he tells his readers that he is using the word "ideas" to name *all* objects of the mind when it is engaged in thinking. I have mentioned these two errors in the preceding chapter, but they are so important that I wish to repeat the points here.

One of the errors can be corrected by remembering the distinction Thomas Aquinas makes between thoughts that are *that which (id quod)* we know and those that are *that by which (id quo)* we know. He affirms *id quo*. Making this distinction amounts to saying that the content of our minds, its cognitive mental content, is something of which we have no direct introspective experience, as contrasted with the noncognitive contents of our mind, our feelings, our aches and pains, our emotions and sentiments. Of these we are directly aware. Cognitive mental content cannot be both. It cannot function to make us aware of the objects of thought and also, at the same time, be that of which we are directly aware.

The second error is equally important. It is the failure to *distinguish* the mind's sensitive faculties from its intellectual powers.* Here the mistake begins not with

*This error is fully exposed in Chapter 2 of *Ten Philosophical Mistakes* (New York: Macmillan, 1985).

Descartes, but with Thomas Hobbes and with John Locke, George Berkeley, and David Hume, and is perpetuated by British empirical psychology since their day, though it is not found in Immanuel Kant and in the post-Kantian idealists.

As a result of this error, combined with the first error mentioned here, cognitive mental content is wrongly said to consist entirely of the components of perceptual thought, as exhibited by other animals as well as humans. These components are sensations, sense-perceptions, memories, and imaginations, including imaginative fictions of the mind.

The components of distinctively human conceptual thought have not yet been mentioned. They are concepts abstracted from sense-experience and conceptual constructs, as well as the intellect's acts of judgment. The intellect's dependence on the sensitive faculties does not obliterate the clear distinction between the senses and the intellect.

One point must be added here. The second of these two mistakes in modern thought does not alter the correction of the first error. When the cognitive mental content is sensitive rather than intellectual, it must still be said that we have no direct experience of our perceptions, memories, and imagination, but only of the objects that this cognitive mental content puts before our minds. We have no experience of our percepts, but only of perceptual objects; no experience of memories, but only of events or scenes remembered; no experience of our imagination, but only of objects imagined.

In addition to our memory of past events and scenes, we can remember how we felt at some earlier time.

It should be added, of course, that we have no awareness or experience of our concepts, but only of the objects they enable us to understand.

2

Let us now consider the nonverbal symbols employed in musical and choreographic scores. The producer of the music and the ballet is imagining the sounds or movements he or she wishes to be played or performed. The nonverbal symbols of these special languages are like the instrumental signs used in our everyday speech. They are all perceptible but meaningless notations until the mind's formal signs give them meaning. The formal signs are acts of imagination; they may even be acts of intellectual imagination if conceptual thought illuminates the mind's imaginative activity.

The same analysis applies to the mind's activity where the productive artist creates works of visual art—paintings and statues. The viewer of these visual works, like the reader of musical and choreographic scores, must engage in acts of imagination, or of intellectual imagination, if the imagination is illuminated by some measure of conceptual thought.

The comparable mental acts are similar even if there is no special language for imagined visual symbols as there is in the case of musical and choreographic scores. But the musical and choreographic symbols engage the

mind in comparable acts of the sensitive faculties. In both cases the mental acts are acts of imagination, or of the intellectual imagination. The acts are not acts of purely conceptual thought, as they are when English words of our everyday speech are used.

What mental acts are involved? What mental acts give meaning to the otherwise meaningless notations that function as the perceptible but meaningless notations that become meaningful English words?

These acts are, in the first place, acts of apprehension. Apprehension of what? Of the objects of perception, memory, and imagination, when the mind conjoins the action of the sensitive and intellectual faculties; and they are apprehensive acts of the intellect alone, when the mind is engaged in purely intellectual thought. In the latter case the mind's acts of apprehension employ concepts abstracted from sense-experience, or conceptual constructs and other fictions of conceptual thought. These conceptual constructs, or mental fictions, are the formal signs that *are* meanings as well as the conveyors of meaning.

Only in the case of perceptual apprehension do we simultaneously assert that the object perceived really exists. In this case alone is the perceptual apprehension *inseparable* from the existential judgment. To think otherwise, to think we can perceive what does not really exist, fails to distinguish normal perception from pathological hallucination.*

*For a fuller explanation of this point, see *Six Great Ideas*, pp. 54–55.

In the case of the mind's acts of apprehension other than the act of perception, we cannot avoid the question that calls for a separate act of judgment. When the object of apprehension is not perceptual, we are always confronted with a question about the existence in reality of the object apprehended. The object may be a conceptual construct, such as black holes or elementary particles in physics, or it may be a philosophical construct, such as God or the intellect itself; it may be an imaginative fiction, such as mermaids or centaurs, or an intellectual fiction, such as the thought of the labor theory of value and capitalist exploitation in Marxist economics.

Confronted with this question of existence in reality, the mental acts of reasoning that are our attempts to answer it involve William of Ockham's principle of parsimony. We are not entitled to posit the real existence of the questionable objects unless, as Ockham tells us, they are indispensable to the explanation of perceptually observed phenomena. Isaac Newton posited the existence of the unobservable ether because he thought it was needed to explain gravitation. Einstein's general theory of relativity and of the four-dimensional manifold of space-time made the ether dispensable; the observed phenomena of gravitation could be otherwise explained.

3

We have now completed an analysis of the mind's contents, acts, and objects, with sufficient detail for our present purposes. What does it tell us about works of music and the ballet, and about works of visual art?

It tells us, first, that these works of art, both as produced and received, fall in the sphere of the sensitive faculties, mainly in the sphere of imagination, whether or not that sphere is suffused with light drawn from the intellect.

It tells us, in the second place, that the nonverbal symbols that constitute the special languages of the arts are like words as the instrumental signs that get the meaning they have from the mind's apprehensive acts.

Finally, it tells us that the meaning of the works we have been considering never involves purely conceptual thought. Purely conceptual thought may be involved in imaginative literature, such as epic, dramatic, and lyric poetry, and in fictional narratives. While these are works of the intellectual imagination, and thus fall into the sphere of sensible objects, their use of words enables them to convey purely conceptual thought, which does not occur in musical and choreographic scores or in paintings and statues.

We shall return to this last point when, in the following chapter, we deal with the Great Ideas and then with the literary aspect of the nonliterary arts in Chapter 8, entitled "With and Without Words."

# CHAPTER 7

# *The Great Ideas*

1

Readers often skip the author's prologue or fail to recall what was said in it. But some may have paid attention and recall what I wrote there autobiographically about the educational problem that led to the writing of this book.

They will remember my involvement in the Paideia reform of basic schooling in this country, especially my concern with the problem of Socratically conducting seminars on the great books and other great works of art, particularly musical compositions and works of visual art.

They will realize that in the preceding chapters the meaning of the word "ideas" was discussed. The Great Ideas have been lurking in the background. Now in this chapter they come to the forefront, and we will deal with them directly and say *what they are* and *what they are not*. I shall try to be as clear as possible about this,

and I shall begin by saying *what they are not* and then explain *what they are.*

### 2

The Great Ideas are not part of the cognitive content of our human minds. Unlike our perceptions, memories, and imagination, and also unlike our concepts and theoretical constructs, the Great Ideas do not occur as the contents or acts of anyone's mind. They are not, like the mental contents just mentioned, formal signs— the intentions of the mind that are meanings and that function to place objects signified before our minds. In short, they are not ideas even in the correct sense of the term, which makes them the means (the *id quo*) whereby we think; they are not thoughts.

They are the objects (the *id quod*) of thought. They are ideas in the Platonic sense of that term, with the correction added that they do not exist in reality. Though conceptual thought is involved in our thinking about them, we do not apprehend them by means of our concepts. This is not to say that the concepts we form and construct do not play a part in our thinking about the Great Ideas, but that thinking involves other acts in addition to its acts of apprehension—its acts of judgment and of reasoning.

Perhaps the most revealing thing to say about the Great Ideas is that there is no trace of them, no reference to them, in scholarly literature before this cen-

tury. Not only can we find no mention of the Great
Ideas in that literature, but neither can we find such
phrases as "the great books" or "the great conversation."

When, in 1921, Professor John Erskine made up a
list of the books that he thought college students at
Columbia University should read if they were to grad-
uate with general honors, he called the books he listed
"Classics of the Western World." He did not use the
phrase "great books."

The great conversation about the Great Ideas was
never mentioned in the course of the seminars he and
others after him conducted at Columbia in the second
decade of this century. All of that came later at the
University of Chicago, where President Robert M.
Hutchins and I taught the same kind of seminars that
Erskine had initiated at Columbia and that Mark Van
Doren and I had conducted there from 1923 to 1929.

Though Hutchins and I called the seminars we con-
ducted "great books seminars" and, for that purpose,
used a somewhat modified version of Erskine's list of
Western classics, such phrases as "the great conversa-
tion" and "the Great Ideas" did not come into existence
until the year 1943. It was then that Senator William
Benton, the publisher of *Encyclopaedia Britannica,*
asked Hutchins and me if we would undertake to edit
a set of the great books that the Britannica company
could publish.

It was then that the Great Ideas were *invented.* I
have italicized the word "invented" because as readers
will see when they learn the story of how they were

compiled and constructed, the Great Ideas came into literary existence as the result of years of intellectual work. They can be called an invention as properly as the plot of a play or a novel can be called an invention when it comes into literary existence as a work of the imagination.

I have told elsewhere the story of the series of events that led to the publication in 1952 of *Great Books of the Western World.** This set contained, in the first two of its fifty-four volumes, a work entitled *The Great Ideas*, otherwise known as *The Syntopicon.*

The story that I am now going to retell explains why and how the Great Ideas were invented and what steps had to be taken to construct *The Syntopicon.*

## 3

When Senator Benton met with President Hutchins and me to propose that we edit a set of great books, he had been a member of the great books seminar that Bob Hutchins and I conducted for some of the trustees of the University of Chicago, as well as for other prominent citizens of Chicago who were leaders of commerce

*Readers interested in previous versions of this story will find these accounts in *A Second Look in the Rearview Mirror*, Chapter 5, pp. 133–153; and in a volume published by Macmillan in 1992, entitled *The Great Ideas: A Lexicon of Western Thought*. That volume contains the 102 essays that I had written for the first edition of *Great Books of the Western World* and that were revised for the second edition published by Britannica in 1990. The subtitle I affixed to that Foreword was "especially for readers who have never seen *The Syntopicon.*"

and industry there and members of its leading law firms. It was wartime and Benton had difficulty in getting reprints of the books assigned for reading in that seminar. His frustration, and his unwillingness to go to the university's library, motivated his proposal to have the Britannica company publish a set of the books.

At our first meeting in the President's office, Bob Hutchins said, No, he did not want to waste his time editing such a set. He said he knew that Benton could sell it, but would not the published set be just attractive furniture in the homes of its purchasers? What would ever get them to read the books if they were not members of seminars like the one in which Benton himself was a member, which met once a week over a two-year period? That amounted to a flat rejection of Benton's proposal.

At this point I intervened, begging for a postponement of two weeks in which I would try to see if I could come up with some editorial device we could add to the set that would enable its purchasers to use the books profitably, even if they were not members of a great books seminar. I was granted the two-week postponement before we reached the final decision to publish or not to publish the proposed set.

Nineteen hundred and forty-two was the fearful year of Stalingrad. It was also the year I wrote *How to Think About War and Peace*. In preparing to write the book, I turned to some of the great books I had read many times to find out what they had to say about war and peace—to such authors as Plato, Thucydides, Tacitus,

Thomas Hobbes, John Locke, Jean-Jacques Rousseau, Immanuel Kant, and the Federalist Papers.

I found very significant passages in all those books, on pages that I had marked when I had read them before; but to my great surprise these passages on war and peace were not underlined. I wondered why that was so. How could I have failed to take note of these passages that now promised to prove so useful to me?

I finally came up with the solution to this puzzling question. When I had read these same books at an earlier time, and these very passages in them, I had other philosophical problems in mind, not war and peace. If war and peace had been on my mind then, I could not possibly have missed these crucial passages.

That led me to think of indexing the great books on all the subjects about which their authors had highly relevant and significant thoughts. If one were to read the great books with all the questions in mind to which they might have answers, that would give us a relatively complete index to the major contributions of the great authors to human thought.

How many questions would we have to ask? How many times would we have to read the great books to find the answers? I had no notion, but that did not prevent me from coming to our second meeting with Benton in Bob Hutchins' office with the proposal that we construct what I then called an "idea index."

How did this solve the problem that caused Hutchins to reject Benton's invitation that he and I edit a set of great books? My answer to that question was that, with

the index I had in mind, purchasers of the set would be able to read *in* the set before they had started to read *through* it, beginning with its first volume and reading every volume completely before going on to the next.

Hutchins had been right in the first place when he said that purchasers of this large set of volumes would be so intimidated by it that, without some help such as weekly seminar discussions, they would not have the courage or the interest to try to make a profitable use of the set they had bought.

Hutchins immediately saw the point of the device I had suggested. So did Benton. Both thought it would do the trick. Benton then asked, as he should have, "How much would it cost to make such an index?" and "How long would it take?"

I should have said that I did not know, but I brashly and imprudently replied: "Two years and about fifty thousand dollars." I lived to regret those errors, which Benton never let me forget.

### 4

The second part of this story is my explanation of why it took eight years at a cost of over $1 million. I could not have known then that it would take all that time and involve a staff of about thirty-five readers and more than seventy-five clerical assistants. There were no computers in those days and no technological advances that would have made shortcuts available.

Since the editorial staff that Hutchins assembled to help him select the great authors and books the set should contain took two years to complete their work, I decided to start at once on my "idea index" by trying to do it for the books of Greek antiquity.

We could be sure that the set would contain Homer, the Greek tragedies and comedies, Herodotus, Thucydides, Plato, and Aristotle. If we could figure out how to construct an index to the thought of these Greek authors, all of whom wrote in the same language, then we might be able to use the same method for constructing an index that included all the authors the set would contain from the Greeks down to the end of the nineteenth century—to Sigmund Freud and William James.

With a relatively small staff of readers, who used ordinary index cards to record their entries, we worked for two years on what we called our "Greek index." At the end of two years, I had to confess that our best efforts at doing ordinary indexing were a complete failure and utterly worthless. Why had we failed so miserably?

To make my answer to that question intelligible to readers, I must first ask them to consider what the ordinary process of indexing a book involves. This book, for example, has an index. A book's index is constructed either by its author or by a competent editor. Its entries, arranged alphabetically, are the important terms used by the author in writing the book; and attached to these terms are page references to passages in which

these terms are pivotal. It is hard work if it is done carefully and intelligently, but there is nothing impossible about it.

Why was it absolutely impossible for us to construct what would be like an ordinary index for the books of the Greek authors in the set? The answer is very simple, indeed, even though it took us two years to discover it.

We were not engaged in indexing the work of a single author. Instead, we were trying to index the works of many authors, more than a dozen. No one in the entire history of indexing had ever tried to do this—to make an index for even two different authors, and certainly not for a great many more than that.

Why not—even if all the authors to be indexed wrote in the same language and lived approximately during the same cultural era? Because, even if they all used words in the same language, they did not use them in exactly the same sense. Even a single author may be prone to ambiguity. And if the books are written by different authors, the words they employ will frequently be used in widely different senses.

One set of entry terms that constitute the elements in an ordinary index will not be available when the entry terms are drawn from books written by many different authors. Even when the authors are as closely related as Plato and Aristotle, many of the entry terms for indexing the dialogues of Plato are not the same as the entry terms for indexing the treatises of Aristotle.

An index to the thought in the great books was clearly

not an ordinary index, and the method of ordinary indexing we had been using in our two years of work on the Greek index simply would not do. We had to invent a different method and do a totally different kind of indexing.

Could that be done? What would it be like? Before I answer these questions, let me say two things. One is that I was both willing to tell Hutchins and Benton that I had failed and was ready to give up. The other is that, by this time, the Board of Editors for the set had selected the authors and works to be included. The numbers were seventy-four authors and 443 works— many times larger than the numbers we encountered in our work on the Greek index. Not only did we now face much larger numbers of authors and works, but we also had works written in many different languages and in many different epochs—in the twenty-five centuries from the time of Homer to the end of the nineteenth century.

If the ordinary method of indexing was impossible to use for just the Greek authors and books, all writing in the same language and living in the same culture and at about the same time, how much more impossible—if there is any meaning to "more than absolutely impossible"—would it be to use the method of ordinary indexing for handling seventy-four authors, and 443 works, written in different languages in different cultures, and in different epochs or eras?

Explaining how we found a totally different method of indexing to do this job is the third step in my story

of how we invented the Great Ideas in the second half of the fourth decade of this century.

Before we come to this third step, I must tell readers about another "higher degree of impossibility." In 1990 we engaged in bringing out a second edition of *Great Books of the Western World*. For this purpose, the 1952 set was enlarged to include more authors, many of them twentieth-century authors. The number of authors in 1990 was 50 more than 74, or 124; and the number of works added to 443 was 63, or a total of 506. This did not cause any increase in the number of Great Ideas, but it did involve an enlargement of the topics in *The Syntopicon*.

## 5

The solution—and the third step in this story—was the invention of a new method of indexing. This led to the invention of the Great Ideas.

The new method can be stated easily in two words—"topical indexing." This is difficult and time consuming; but it is not impossible to execute.

Some books have topical tables of contents, which are outlines of a book's argument or logical structure. Here the topics are, in effect, brief statements of the author's principal assertions. Topical indexing of two or more books is not like that at all.

You cannot have a topical table of contents for the thought of more than one author. But when you are

dealing, as we were, with a large number of authors and an even larger number of works, you can construct an outline of the topics being discussed by them because, in this case, the topics are not assertions, but the very opposite. They are like questions.

As readers will see, they are not stated in the form of questions. Their grammatical form, instead, is a simple or complex phrase that is capable of being the heading for many different, opposing, contrary or contradictory, assertions, or thoughts.

The reason the "idea index" to the great books that we were attempting to create came to be called a syntopicon was that it was precisely what it became—a vast collection of topics, outlined systematically or logically, not alphabetically, and set forth in 102 separate Outlines of Topics, one for each of the 102 Great Ideas.

Why 102? And how were they found? Were they invented or discovered?

The answer to the last question should probably be *both* discovered and invented. When we invented the method of topical indexing, we also discovered that each set of topics set forth the fairly complex interior structure of some major object of philosophical or scientific thought. So the first step in our new method of topical indexing was to develop an inventory of the principal objects of philosophical and scientific thought in the twenty-five centuries of Western civilization.

Constructing that inventory was a staff operation. After consulting with one another, we finally compiled

a list of about five hundred terms that had sufficient importance and significance in all the chronological eras and cultural epochs of Western civilization to be candidates for selection as principal objects of thought. We soon discovered that we could eliminate many of these terms, either as subordinate to other terms or as overlapping with other terms; and we finally reduced our inventory of principal terms to 102. The next step was to replace "principal terms" with "Great Ideas."

Why just 102? It could have been 102 plus or minus ten because that decision was pragmatic, not logical. It was a matter of convenience. If many were added to make it more than 102, the result would be to enlarge, so we kept combinable objects of thought together.*

A topic, as the Greek etymology of the word indicates, is a *place*. Logically considered, a topic is a place where thinking minds meet to discuss and, in the ensuing discussion, to differ, to agree or disagree, and to argue with one another.

The formulation of the 102 Outlines of Topics was the work of a large staff of readers and editors, and it consumed the better part of three years. At meetings that occurred twice a week, members of the staff suggested rewordings of or additions to the Outlines of Topics intially prepared by my associate editor and me. These calls for additional or reworded topics came from read-

---

*On this point of convenience, readers will find a fuller explanation of why we ended with 102, rather than ten more or ten less, in my Foreword to *The Great Ideas*, pp. xv–xvl.

ers who complained that they needed a new or different topical phrasing to accommodate the great author to whom they had been assigned. In this process, the 102 Outlines of Topics were revised fifteen or more times; and a similar revision of the Outlines of Topics occurred in 1988–89 when we were amending *The Syntopicon* for the second edition of *Great Books of the Western World*.

Some of the topics were simple; some complex, with related aspects of the same theme placed before and after the punctuation mark of a colon (:). Sometimes topical revision called for a new topic; sometimes it called for a new pre-colon or a new post-colon phrase.

In the first edition of the set, Bob Hutchins, as Editor-in-Chief, wrote an introductory volume entitled *The Great Conversation*. By the time he came to write that essay, work on *The Syntopicon* was sufficiently advanced so he could point to it as demonstrative evidence that, topic by topic, an instructive discussion had occurred in which major contributors to Western thought had participated over the centuries.

There are 102 chapters in *The Syntopicon*, one for each of the Great Ideas. They are arranged alphabetically, in one volume from ANGELS to LOVE, in a second volume from MAN to WORLD.

Each chapter has five parts, in the following order: (1) an introductory essay about a Great Idea, (2) an Outline of Topics for that idea, (3) the reference section, in which passages in the great books are cited for their

relevance to that Great Idea and to one or another topic subsumed under it, (4) cross-reference to related topics under other ideas, and (5) a list of additional readings, other books by the great authors who were included in the set, as well as suggested readings in works by other authors during the last twenty-five centuries.

At the end of the second volume of *The Syntopicon* is a section entitled "Inventory of Terms." This contains a list of over two thousand terms that are related in one way or another to the Great Ideas.

# 6

On the following pages, I have reproduced one of *The Syntopicon*'s chapters—Chapter 50 on LOVE. The reproduction does not include the Introductory section of that chapter, my essay on LOVE, but it reproduces the other four sections of Chapter 50.*

The Outline of Topics that sets forth the interior structure of the Great Idea LOVE is taken from the Second Edition of *Great Books of the Western World,* as readers will discover when they see cited in the reference section of the chapter the names of many twentieth-century authors.

I would also like to call readers' attention to the fact that some of the topics (see, for example, 3.) are "logical hangers," or headings that subsume other topics, but

*Readers will find my essay on LOVE in *The Great Ideas*, pp. 452–460, and in *The Syntopicon*, in *Great Books of the Western World* (2nd Edition), Volume 1, pp. 811–819.

are themselves topics under which references to relevant passages in the great books are not cited.*

# LOVE

## Outline of Topics

1. The nature of love
   1a. Conceptions of love and hate: as passions and as acts of will
   1b. Love and hate in relation to each other and in relation to pleasure and pain
   1c. The distinction between love and desire: the generous and acquisitive aims
   1d. The aims and objects of love
   1e. The intensity and power of love: its increase or decrease; its constructive or destructive force
   1f. The intensity of hate: envy and jealousy
2. The kinds of love
   2a. Erotic love as distinct from lust or sexual desire
      (1) The sexual instinct: its relation to other instincts
      (2) Infantile sexuality: polymorphous perversity
      (3) Object-fixations, identifications, and transferences: sublimation

*The Syntopicon: An Index to the Great Ideas,* in *Great Books of the Western World* (2nd Edition), Volume 1, pp. 820–832. Reprinted by permission from *Great Books of the Western World,* © 1990 by Encyclopaedia Britannica, Inc.

(4) The perversion, degradation, or pathology of love: infantile and adult love

2b. Friendly, tender, or altruistic love: fraternal love

(1) The relation between love and friendship

(2) Self-love in relation to the love of others: vanity and self-interest

(3) The types of friendship: friendships based on utility, pleasure, or virtue

(4) Patterns of love and friendship in the family

(5) Friendship as a habitual association

2c. Romantic, chivalric, and courtly love: the idealization and supremacy of the beloved

2d. Conjugal love: its sexual, fraternal, and romantic components

3. The morality of love

3a. Friendship and love in relation to virtue and happiness

3b. The demands of love and the restraints of virtue: moderation in love; the order of loves

3c. The conflict of love and duty: the difference between the loyalties of love and the obligations of justice

3d. The heroism of friendship and the sacrifices of love

4. The social or political force of love, sympathy, or friendship

4a. Love between equals and unequals, like and unlike: the fraternity of citizenship

4b. The dependence of the state on friendship and

patriotism: comparison of love and justice in relation to the common good

4c. The brotherhood of man and the world community

5. Divine love

5a. God as the primary object of love

(1) Man's love of God in this life: respect for the moral law

(2) Beatitude as the fruition of love

5b. Charity, or supernatural love, compared with natural love

(1) The precepts of charity: the law of love

(2) The theological virtue of charity: its relation to the other virtues

5c. God's love of Himself and of creatures

## References

50. LOVE

References are listed by volume number (in bold type), author's name, and page number. Bible references are to book, chapter, and verse of the Authorized King James version of the Bible. The abbreviation "esp" calls the reader's attention to one or more especially relevant parts of a whole reference; "passim" signifies that the topic is discussed intermittently rather than continuously in the work or passage cited. Where the work as a whole is relevant to the topic, the page numbers refer to the entire work. For general guidance in the use of *The Syntopicon*, consult the Introduction.

THE GREAT IDEAS

1. The nature of love

1a. Conceptions of love and hate: as passions and as acts of will

50. LOVE

1b. Love and hate in relation to each other and in relation to pleasure and pain

    **4** Euripides, 277–295

    **6** Plato, 18–19, 21, 121–122, 333–334

    **8** Aristotle, 168, 407–410 passim, 420, 423–424, 425, 429, 614

  **11** Lucretius, 55–56

  **12** Virgil, 143–153

  **16** Augustine, 15–16

  **17** Aquinas, 726–727, 731–733, 734–735, 743–744, 746–747, 788

  **18** Aquinas, 527–530

  **19** Dante, 6–7, 67–68

  **19** Chaucer, 199, 228

  **21** Hobbes, 61–62, 77

  **25** Shakespeare, 103–141, 469–470

  **28** Spinoza, 634, 636–638, 640–645

  **31** Racine, 308

  **33** Locke, 176–177

  **35** Rousseau, 344

  **49** Darwin, 312

  **52** Dostoevsky, 295–297, 383–385

  **53** James, William, 391–392, 717–718

  **54** Freud, 418–421, 659, 708–711, 724–725, 752–754, 766, 789–790

  **59** Proust, 355–356

  **60** Woolf, 92

THE GREAT IDEAS

50. LOVE

1e. The intensity and power of love: its increase or decrease; its constructive or destructive force

THE GREAT IDEAS

1f. The intensity of hate: envy and jealousy

THE GREAT IDEAS

Frank Stella (American, born 1936), *Raqqa II*, 1970, North Carolina Museum of Art, Raleigh. Gift of Mr. and Mrs. Gordon Hanes. © 1994 F. Stella/ARS, New York.

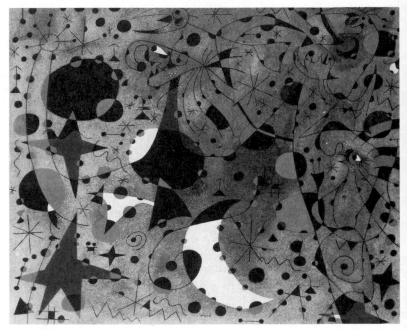

Joan Miró, *The Nightingale's Song at Midnight and Morning Rain*. From the Constellation series. Palma de Mallorca, September 4, 1940. Perls Galleries, New York, © 1994 Estate of J. Miró/ARS, New York.

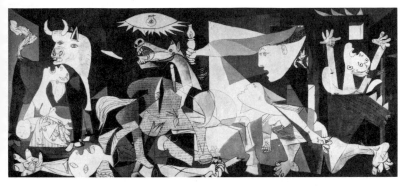

Pablo Picasso, *Guernica*, 1937, Museo Del Prado, Madrid, © 1994 ARS, New York/SPADEM, Paris.

# SYMPHONY No. 37

## in G Major, K.444

Said to be composed in 1783.

Symphony No. 37 by Wolfgang Amadeus Mozart. Courtesy Dover Publications, Inc., New York

# Fugue in C Minor

## BWV 575

Fugue in C Minor by Johann Sebastian Bach. Courtesy Dover Publications, Inc., New York.

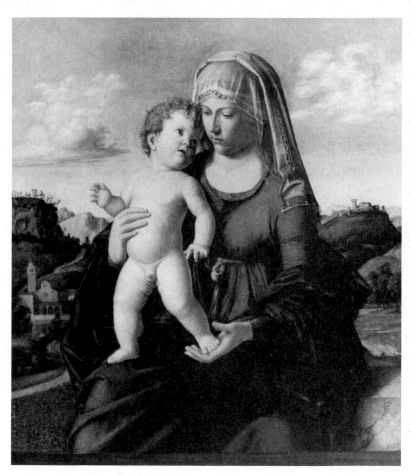

Giovanni Battista Cima da Conegliano (Italian, c. 1459–1517/18), *Madonna and Child in a Landscape*, c. 1496–99, North Carolina Museum of Art, Raleigh. Purchased with funds from the State of North Carolina.

James Abbott McNeill Whistler, *Arrangement in Gray and Black* (also known as *The Mother of the Artist*), Musée d'Orsay, Paris.

Piet Mondrian, *Composition*, 1929, Solomon R. Guggenheim Museum, New York, Gift, Estate of Katherine S. Dreier, 1953. Photo: David Heald © The Solomon R. Guggenheim Foundation, New York. Mondrian Estate/ Holtzman Trust.

50. LOVE

2. The kinds of love

2a. Erotic love as distinct from lust or sexual desire

THE GREAT IDEAS

50. LOVE

2a(1) The sexual instinct: its relation to other instincts

2a(2) Infantile sexuality: polymorphous perversity

2a(3) Object-fixations, identifications, and transferences: sublimation

52 Ibsen, 572–574
53 James, William, 804–805
54 Freud, 18, 84–86, 90–96, 97–106, 111–118, 409–410, 415–418, 547–549, 569–573, 583–591, 593–599, 611, 619–622, 659, 680, 718, 724–728, 733–735, 847–850, 859, 861–862
59 Pirandello, 251–252
59 Proust, 394–400
59 Mann, 487–512 passim esp 488–489, 493–499, 500–502
59 Joyce, 570–576
60 Lawrence, 148–152
60 Eliot, T. S., 172

2b. Friendly, tender, or altruistic love: fraternal love

Old Testament: *Leviticus,* 19:17–18, 33–34 / *Deuteronomy,* 10:18–19 / *I Samuel,* 18:1–4; 19:1–7; 20 / *II Samuel,* 1 / *Psalms,* 133 / *Proverbs,* 17:17–18; 18:19, 24
Apocrypha: *Ecclesiasticus,* 6:1, 13–17, 7:18–19; 27:16–21; 29:10, 15; 37:1–2, 6; 40:23–24
New Testament: *Matthew,* 5:21–26 / *I Thessalonians,* 4:9–10 / *I Peter,* 3:8 / *II Peter,* 1:5–7 / *I John,* 3:11–17

3 Homer, 41–42, 71, 189–206, 221–233, 238–240, 273–278
4 Sophocles, 184
4 Euripides, 593–594
6 Plato, 14–25, 124–129
8 Aristotle, 406–426
11 Epictetus, 158–160
12 Virgil, 238–245

THE GREAT IDEAS

2b(1) The relation between love and friendship

50. LOVE

2b(2) Self-love in relation to the love of others: vanity and self-interest

THE GREAT IDEAS

2b(3) The types of friendship; friendships based on utility, pleasure, or virtue

50. LOVE

2b(4) Patterns of love and friendship in the family

THE GREAT IDEAS

50. LOVE

2b(5) Friendship as a habitual association

2c. Romantic, chivalric, and courtly love: the idealization and
   supremacy of the beloved

THE GREAT IDEAS

2d. Conjugal love: its sexual, fraternal, and romantic components

THE GREAT IDEAS

50. LOVE

3. The morality of love

3a. Friendship and love in relation to virtue and happiness

THE GREAT IDEAS

3b. The demands of love and the restraints of virtue: moderation in love; the order of loves

3c. The conflict of love and duty: the difference between the loyalties of love and the obligations of justice

THE GREAT IDEAS

3d. The heroism of friendship and the sacrifices of love

50. LOVE

4. The social or political force of love, sympathy, or friendship

THE GREAT IDEAS

4a. Love between equals and unequals, like and unlike: the fraternity of citizenship

50. LOVE

4b. The dependence of the state on friendship and patriotism: comparison of love and justice in relation to the common good

**THE GREAT IDEAS**

4c. The brotherhood of man and the world community

12 Virgil, 87–88
16 Augustine, 412, 583–584
18 Aquinas, 514–517
23 Montaigne, 513–514
28 Spinoza, 682
35 Rousseau, 369, 437
39 Kant, 449–458, 586–587
49 Darwin, 317
50 Marx-Engels, 428
51 Tolstoy, 69, 198–203 passim, 244–245, 466
52 Dostoevsky, 127–128, 171–178 esp 174–175
54 Freud, 674, 691–692, 755–761, 785–788

5. Divine love

5a. God as the primary object of love

Old Testament: *Deuteronomy*, 6:4–9
New Testament: *Matthew*, 6:33
11 Epictetus, 149, 230
16 Augustine, 1, 26–30, 92–93, 102, 129, 401–402, 437,
476, 744–745
17 Aquinas, 313–314, 615, 621–622
18 Aquinas, 340–341, 490, 511–512, 522–523
19 Dante, 63–64, 67–68, 83–86, 90–91, 95,
123–124
23 Erasmus, 41
28 Spinoza, 690, 694
39 Kant, 325–327
51 Tolstoy, 373–377 passim, 525–526
52 Dostoevsky, 133–144 passim

THE GREAT IDEAS

5a(1) Man's love in this life: respect for the moral law

Old Testament: *Exodus*, 20:5–6 / *Deuteronomy*, 5:9–10;
6; 7:9–11; 11:1, 13, 22; 30:6, 15–20 / *Joshua*,
22:1–6 / *Psalms* passim / *Isaiah*, 29:8–9
Apocrypha: *Ecclesiasticus*, 2; 34:16
New Testament: *Matthew*, 22:36–38 / *Mark*, 12:30–32 /
*Luke*, 10:25–28 / *John*, 14:15, 21, 23–24 / *Acts*,
20:22 –24; 21:7–15 / *Romans*, 5:5 / *I Corinthians*,
8:1–3 / *Ephesians*, 3:14–21/ *I John*, 2:5, 12–17;
4:19–5:3
11 Epictetus, 115, 149, 192–198, 230
16 Augustine, 21–22, 63–64, 92, 102–112, 350–351,
593, 646–647, 709–710, 711–712, 712–713, 715–716
17 Aquinas, 324–325
18 Aquinas, 74–75, 85–86, 482–483, 491–500, 520–
527 esp 523–524, 629–632
19 Dante, 83–86, 103–104, 123–124
19 Chaucer, 273
21 Hobbes, 240
28 Bacon, 80–81
28 Descartes, 314–315
28 Spinoza, 681
29 Milton, 178–179
30 Pascal, 78–80, 245–247, 255–259, 266
39 Kant, 321–329 esp 326–327, 375, 504–505, 593,
611
43 Hegel, 325–326
43 Kierkegaard, 432
43 Nietzsche, 485

**51** Tolstoy, 525–526, 608
**52** Dostoevsky, 133–134 passim
**58** Huizinga, 326–327

5a(2) Beatitude as the fruition of love

**16** Augustine, 85–86, 691–696, 716
**17** Aquinas, 322–325, 639–640
**18** Aquinas, 376, 495–496, 498–499, 519–520, 528–529, 629–630, 1037–1040, 1042–1066
**19** Dante, 63–64, 90–133
**28** Spinoza, 681, 692–697
**29** Milton, 66
**39** Kant, 346–347

5b. Charity, or supernatural love, compared with natural love
New Testament: *I Corinthians*, 13
**16** Augustine, 63–64, 102–112, 142–143, 476, 744–745
**17** Aquinas, 310–314, 734–736
**18** Aquinas, 340–341, 347–349, 490–491, 506–507, 511–512, 538–539
**19** Dante, 63–64, 83–86, 99–102
**21** Hobbes, 240
**28** Bacon, 2–4
**29** Milton, 331–332
**30** Pascal, 326–327
**41** Boswell, 392
**43** Nietzsche, 488
**51** Tolstoy, 214–218, 465, 617
**52** Dostoevsky, 127–128 passim
**54** Freud, 691–692, 786

THE GREAT IDEAS

## 5b(1) The precepts of charity: the law of love

Old Testament: *Leviticus*, 19:17–18, 33–34 / *Deuteronomy*, 10:12, 18–19; 11:1, 13, 22; 13:3–4; 24:19–22; 30:6, 16 / *Proverbs*, 10:12; 25:21–22
Apocrypha: *Ecclesiasticus*, 4:1–10; 28:1–8; 29
New Testament: *Matthew*, 5:20–26, 38–48; 22:34–40 / *Mark*, 12:28–34 / *Luke*, 6:27–38; 10:25–37/ *John*, 13:34–17:26 passim / *Romans*, 12:9–21; 13:8–10 / *II Corinthians*, 2:4–11; 6; 8:7–8 / *Galatians*, 5 / *Ephesians*, 4:1–2, 13–16, 32: 5:1–2 / *Philippians*, 1:1–11; 2:1–2 / *Colossians*, 3:12–15 / *Hebrews*, 10:24–25; 13:1–3 / *I John* / *II John*

16 Augustine, 350–351, 657–661, 709–715
18 Aquinas, 72–73, 211–212, 245–247, 321–337, 501–527, 592–598, 630–632
19 Dante, 58, 103–104
19 Chaucer, 282, 349–350
20 Calvin, 92–93, 188–189
24 Shakespeare, 427
29 Milton, 331–332
30 Pascal, 91–94, 293–295 passim
33 Locke, 1–2
34 Voltaire, 194–195
44 Tocqueville, 307
49 Darwin, 312
51 Tolstoy, 214–215, 375–376, 377, 525–526
52 Dostoevsky, 27–29, 39–40, 87–88, 131–144 passim, 153–178 passim
54 Freud, 786
57 Veblen, 140–141

50. LOVE

5b(2) The theological virtue of charity: its relation to the other virtues

5c. God's love of Himself and of creatures

Old Testament: *Deuteronomy*, 7:6–15; 10:15, 18 / *Psalms* passim / *Song of Solomon* / *Isaiah*, 43; 63:7–9 / *Jeremiah*, 13:11; 31 / *Ezekiel*, 16 / *Hosea* / *Jonah*, 4

Apocrypha: *Wisdom of Solomon*, 11:22–26; 12:13–16; 16:20–29 / *Ecclesiasticus*, 11:14–17; 16:11–17:32; 33:10–15

New Testament: *Matthew*, 6:25–34; 7:7–11; 10:29–31 / *Luke*, 11:1–13; 12:6–7, 22–28 / *John*, 3:16–21; 13:31–17:26 / *Romans*, 8:29–39 / *Ephesians*, 3:14–20; 5:1–2 / *Titus*, 3:3–7 / *I John*, 3:1–2, 16; 4:7–5:5 / *Revelation*, 3:19–21

THE GREAT IDEAS

## Cross-References

*For other references regarding:*

The basic psychological terms in the analysis of love, *see* DESIRE 3C; EMOTION 1, 2–2C; PLEASURE AND PAIN 7a.

The comparison of love and knowledge, *see* KNOWLEDGE 4d.

The objects of love, *see* BEAUTY 3; DESIRE 1, 2b; GOD 3c; GOOD AND EVIL 1a, 3c; TRUTH 8e; WILL 7d.

Sexual instincts, sexual love, and their normal or abnormal development, *see* DESIRE 4b–4d; EMOTION 1c, 3c–3c(3); HABIT 3–3a; PLEASURE AND PAIN 4b, 7b, 8b–8c; TEMPERANCE 2, 6a–6b.

Conjugal love and its components, *see* FAMILY 7a.

Moral problems raised by love, *see* DUTY 8; JUSTICE 3; OP-POSITION 4d; PLEASURE AND PAIN 8b; SIN 2b; TEMPER-ANCE 6a–6b; VIRTUE AND VICE 6e.

The role of friendship in the life of the individual, the family, and the state, *see* FAMILY 7c; HAPPINESS 2b(5); STATE 3e; VIRTUE AND VICE 6e.

The brotherhood of man and the world community, *see* CIT-IZEN 8; MAN 11b; STATE 10f; WAR AND PEACE 11d.

Man's love of God, or charity, as a theological virtue, *see* DESIRE 7b; GOD 3c; VIRTUE AND VICE 8d(3), 8f; WILL 7d; the fruition of this love in eternal beatitude, *see* HAPPINESS 7c–7c(2); IMMORTALITY 5f.

God's love of Himself and of His creatures, *see* GOD 5h; GOOD AND EVIL 2a.

## Additional Readings

Listed below are works not included in *Great Books of the Western World,* but relevant to the idea and topics in this chapter. These works are divided into two groups:

I. Works by authors represented in this collection. This list is in approximate chronological order.

II. Works by authors not represented in this collection. These authors are listed alphabetically within the era in which they lived.

For full bibliographic citations for the works listed, consult the Bibliography of Additional Readings which follows the last chapter in Volume 2.

THE GREAT IDEAS

## I.

Plutarch. "On Envy and Hate," "How to Tell a Flatterer from a Friend," "On Brotherly Love," "Dialogue on Love," in *Moralia*

Augustine. *Of Continence*

―――. *Of Marriage and Concupiscence*

Thomas Aquinas. *Quaestiones Disputatae, De Caritate*

―――. *Summa Theologica*, PART 11–11, QQ 106–107, 114–119, 151–154

―――. *Two Precepts of Charity*

Dante. *The Convivio (The Banquet)*

―――. *La Vita Nuova (The New Life)*

Bacon, F. "Of Love," "Of Friendship," "Of Followers and Friends," in *Essayes*

Pascal. *Discours sur les passions de l'amour*

Molière. *Le misanthrope (The Man-Hater)*

Racine. *Andromache*

Hume. *A Treatise of Human Nature*, BK 11, PART 11

Voltaire. "Charity," "Friendship, "Love," "Love of God," "Love (Socratic Love)," in *A Philosophical Dictionary*

Rousseau. *Julie*

Smith, A. *The Theory of Moral Sentiments*

Kierkegaard. *Either/Or*

―――. *Stages on Life's Way*

―――. *Works of Love*

Goethe. *Elective Affinities*

―――. *The Sorrows of Young Werther*

Balzac. *At the Sign of the Cat and Racket*

Dickens. *David Copperfield*

Tolstoy. *Anna Karenina*

50. LOVE

## II.
### THE ANCIENT WORLD (TO 500 A.D.)

THE GREAT IDEAS

### THE MIDDLE AGES TO THE RENAISSANCE (TO 1500)

Abelard. *Letters*
Albo. *Book of Principles (Sefer ha-Ikkarim)*, BK 111, CH 35
André le Chapelain. *The Art of Courtly Love*
Anonymous. *Amis and Amiloun*
_____. *Aucassin and Nicolette*
_____. *Sir Gawain and the Green Knight*
_____. *The Song of Roland*
_____. *Tristan and Iseult*
_____. *Valentine and Orson*
Apuleius. *The Golden Ass*
Bernard of Clairvaux. *On Loving God*, CH 7
Boccaccio. *The Decameron*
_____. *Il Filocolo*
Chrétien de Troyes. *Arthurian Romances*
Francis of Assisi. *The Little Flowers of St. Francis*, CH 21–22
Gower. *Confessio Amantis*
Guillaume de Lorris and Jean de Meun. *The Romance of the Rose*
Petrarch. *Sonnets*
_____. *The Triumph of Love*
Pico della Mirandola, G. *A Platonick Discourse upon Love*
Thomas à Kempis. *The Imitation of Christ*, BK 11; BK 111, CH 5–10
Villon. *The Debate of the Heart and Body of Villon*

### THE MODERN WORLD (1500 AND LATER)

Abe Kōbō. *The Woman in the Dunes*
Ariosto. *Orlando Furioso*
Beattie, A. *Chilly Scenes of Winter*
Bowen. *The Death of the Heart*

50. LOVE

———. *The Heat of the Day*
Bradley, F. H. *Aphorisms*
———. *Collected Essays*, VOL 1(3)
———. *Ethical Studies*, VII
Brontë, C. *Jane Eyre*
Brontë, E. *Wuthering Heights*
Browning, E. B. *Sonnets from the Portuguese*
Burton. *The Anatomy of Melancholy*, PART 111, SECT 1–111
Byron. *Don Juan*
Carew. *A Rapture*
Cary. *A Fearful Joy*
Castiglione. *The Book of the Courtier*
Congreve. *The Way of the World*
Corneille. *La Place Royale*
Crashaw. *The Flaming Heart*
D'Arcy. *The Mind and Heart of Love*
Dickinson, E. *Collected Poems*
Donne. *Songs and Sonnets*
Dryden. *All for Love*
Edwards, R. *Damon and Pithias*
Ellis. *Studies in the Psychology of Sex*
Emerson. "Love," in *Essays*, 1
Fielding. *Tom Jones*
Flaubert. *Madame Bovary*
Garciá Lorca. *Blood Wedding*
Garcia Márquez. *Love in the Time of Cholera*
Gide. *Strait Is the Gate*
Gourmont. *The Natural Philosophy of Love*
Hardy, T. *Far from the Madding Crowd*
Harris, J. R. *Boanerges*
Hartmann, E. *Philosophy of the Unconscious*, (c) XIII (3)

THE GREAT IDEAS

Hawthorne. *The Blithedale Romance*
Hurd. *Letters on Chivalry and Romance*
John of the Cross. *The Living Flame of Love*
Keats. "The Eve of St. Agnes"
Kundera. *The Joke*
———. *The Unbearable Lightness of Being*
La Fayette. *The Princess of Cleves*
Lewis, C. S. *The Allegory of Love*
Malebranche. *The Search After Truth*, BK IV, CH 5–13
Manzoni. *The Betrothed*
Marvell. "To His Coy Mistress"
Menninger. *Love Against Hate*
Meredith. *Modern Love*
Michelangelo. *Sonnets*
Nabokov. *Lolita*
Neruda. *Twenty Love Poems and a Song of Despair*
Nygren. *Agape and Eros*
Patmore. *Mystical Poems of Nuptial Love*
Peirce, C. S. *Collected Papers*, VOL VI, par 287–317
Poe. *"The Fall of the House of Usher"*
Richardson, S. *Pamela*
Rossetti. *The House of Life*
Rostand. *Cyrano de Bergerac*
Rougemont. *Love in the Western World*
Santayana. *Interpretations of Poetry and Religion*, CH 5
———. *Reason in Society*, CH I, 7
Scheler. *The Nature of Sympathy*
Schlegel, F. *Lucinde*
Schleiermacher. *Soliloquies*
Schopenhauer. *The World as Will and Idea*, VOL III, SUP,
  CH 44

Scruton. *Sexual Desire*

Sidgwick, H. *The Methods of Ethics*, BK 1, CH 7;     BK 111, CH 4

Sidney, P. *Astrophel and Stella*

Spenser. *Epithalamion*

———. *The Faerie Queene*, BK IV

———. *An Hymne of Heavenly Love*

Stendhal. *The Charterhouse of Parma*

———. *Love*

———. *The Red and the Black*

Stephen, L. *The Science of Ethics*

Stevenson. *Virginibus Puerisque*

Synge. *Deirdre of the Sorrows*

Taylor, J. *A Discourse of the Nature, Offices and Measures of Friendship*

———. "The Marriage-Ring," in *Twenty-Five Sermons*

Tillich. *Love, Power, and Justice*

Tirso de Molina. *The Love Rogue*

Turgenev. *Liza*

Tyler. *Dinner at the Homesick Restaurant*

Wedekind. *Pandora's Box*

Wilde. *The Importance of Being Earnest*

Williams, T. *A Streetcar Named Desire*

There is one further comment that I must make concerning our editorial work on the production of *The Syntopicon*. I said earlier that the 102 Great Ideas we had selected were the principal objects of Western philosophical and scientific thought. This must be amplified somewhat to accommodate the great authors in the set who were theologians, mathematicians, historians, and biographers.

To this enumeration of the fields of thought and scholarship that are represented by the great authors in the set, we must now consider the great writers of imaginative literature—the poets, essayists, dramatists, novelists, and writers of imaginative fiction. Writers of this kind constitute about one-fourth of all the great authors in the set.

The problem that confronted us in our work on *The Syntopicon* was this: Citing relevant references, topic by topic, to works that fall in the categories of subject matter mentioned earlier, was no problem. The problem was how to cite relevant passages in the works of imaginative literature or fiction.

We found that we could do that in three ways. (1) In some cases the author speaks, as do Henry Fielding in *Tom Jones,* Leo Tolstoy in *War and Peace,* or William Shakespeare and John Milton in their sonnets. (2) In some cases the fictional characters in plays or novels express thoughts. Shakespeare's *Hamlet* does that throughout the play. (3) The third way is a little more difficult to explain. Topic 2d, under LOVE is worded "Conjugal love: its sexual, fraternal, and romantic components." Under it, readers will find the citation of relevant passages in a great many novels and stories. Some of these passages are cited because episodes in the narratives are concrete exemplifications—rather than explicit statements—of one or another point in that topic.

This third way of handling works of imaginative literature in *The Syntopicon* is of great importance to us for

an obvious reason. These works of literature are works of fine art, comparable to musical compositions and works of visual art. If they can be cited as relevant to topics under the Great Ideas, why is there any difficulty about citing works of music or of visual art as significantly relevant to the Great Ideas and their constituent topics?

Why does it make such a difference that works of imaginative literature are verbally composed, whereas musical and visual works are contrived out of nonverbal symbols?

I will try to explain why it does in the next chapter, which I have entitled "With and Without Words." In the remainder of this chapter, I would like to say a few more words about the various meanings of the word "great" as an adjective affixed to books, authors, ideas, and conversation.

## 7

In our use of the adjective "great" we were guided by two criteria. In relation to the books we judged to be great, the first criterion was the fact that they were endlessly rereadable. One, two, or three readings is enough or more than enough for most books, but it does not suffice in their case. The great books are the books that we can return to again and again with profit and pleasure. We always find in them things that we never saw before. Even great books in physics and mathematics are endlessly rereadable or studiable.

The second criterion applies to both the great books

and the great authors. It is that they contain much of great significance and relevance to the Great Ideas. That is what the great conversation is all about. From this fact, I think it is reasonable to conclude that the primary use of the adjective "great" is its use in the phrase "great ideas."

What is of interest to us in this fact is, as I have pointed out in our consideration so far of works of music and of the visual arts, that this second criterion does not apply. However, the first criterion of judgment obviously does.

Any competent expert in the field of these nonverbal arts would, I believe, testify that great musical compositions are those works that we wish to listen to again and again. We find that we can never exhaust what they mean to us. As they are endlessly sources of pleasure and profit to us, we are tireless in our auditing of them. The same is true for the great paintings and statues. We can never see in them all there is to see without viewing them endlessly.

In this chapter let us remember the negative position we have so far taken—that the great works of music and visual art are not significantly relevant to the Great Ideas in the same way that the great works of imaginative literature are.

The reason for this negative posture with regard to them is the fact that the medium in which they are produced is that of the senses. It is the medium of perceptual rather than of conceptual thought. It is also that the language in which they are created consists of nonverbal symbols rather than words. In a nonverbal

language, discussion cannot occur; and the artists using nonverbal symbols cannot engage in discussion, in agreement or disagreement, and in disputation.

I am postponing until the next chapter a positive statement of the great value that these nonverbal works of art have for us, and the part that they play in our lives. One example here may suffice for the time being.

Consider a great portrait painting, one that experts in the field of painting judge to be great by the criterion of our tireless return to the viewing of it for the pleasure and profit we derive from viewing it again and again. Let us suppose that you would find it a great painting by this criterion even if you did not know who the person was that the artist portrayed. For you, under these circumstances, what would be the aesthetic value of the painting?

The answer is, of course, its beauty—its subjective beauty—its beauty in the eye of the beholder.

This has been defined by Thomas Aquinas and Immanuel Kant as the disinterested pleasure one derives from apprehending a work of art. That aesthetic pleasure is one that we treasure; and, as Aristotle and J. S. Mill tell us, the persons who have learned to place a high value on such pleasure are saved from resorting to lower pleasures—pleasures of the flesh—in the scale of human goods.

# CHAPTER 8

# *With and Without Words*

1

Before we get into the main considerations of this chapter, let me first state the distinction between pure and hybrid works of art. By "pure" I mean all works of music and of the visual arts devoid of verbal titles and nonverbal works that are not conjoined with literary components. In short, these works have no literary aspects, where that means some dependence for their meaning on words instead of on their beauty created entirely in terms of the nonverbal symbols that are their special languages.

I am excluding here, in the case of music, the use of words to state the opus number of the piece or the key and tempo in which it is written.

In music, some examples of hybrid works of art are operas, lyrics set to music for the sake of vocal rendition, and, of course, all programmatic music where the verbally written program does more than comment on the musical structure of the composition.

In the visual arts, hybrid works are religious and historical paintings that have their religious and historical significance compactly expressed in the verbal title, as do all the Madonna and infant Jesus paintings of the Italian Renaissance or a painting such as that of Napoleon on Elbe. Also included here are all etchings that are designed to illustrate a great poem, such as William Blake's illustrations for *Paradise Lost*.

In contrast are all pieces of music that have only an opus number and all paintings that have only a verbal title, such as Franz Kline's "Horizontal II," in which the artist used words only to say what he had done in the color language of painting. In some cases the critics or the public have given a painting a verbal title that was not the painter's own title—for example, "Whistler's Mother," which Whistler entitled "Arrangement in Grey and Black."

2

Let us now consider musical compositions, paintings, and statues that are judged great by competent experts by reference to the criterion of their endless repeatability. In the preceding chapter we were negative about the greatness of such works of art in terms of their relevance to the Great Ideas. Here let us attempt to be positive in our affirmation of the significance of such works of art to the Great Ideas. Making this affirmation, two facts should be noted:

(1) One is the fact that single works of great music and single great paintings are relevant to only a few of the Great Ideas, whereas, in contrast, a single great book is often relevant to many Great Ideas and to many of the topics under each idea.

(2) If we consider the artists themselves rather than their works, most of the great authors produce works that often have relevance to more than seventy-five or eighty of the Great Ideas and to hundreds of topics. This is not true of mathematicians or historians. Their works usually have a much more limited relevance to the Great Ideas and to many fewer topics. Considering all the works of art that musicians and painters produce, either taking them one by one or all together, we will find that they can be cited as relevant to a relatively small number of the Great Ideas and to very few topics under them.

## 3

Now let us consider precisely how the nonverbal works of art express their relevance to the Great Ideas. Let us take, for example, Pablo Picasso's painting *Guernica*, which is housed in a museum of its own, annexed to the Prado in Madrid. There can be no doubt of its relevance to war in number 98 of the 102 Great Ideas (WAR AND PEACE).

Let us suppose that Picasso had said in words what we can suppose he meant about war in that famous

painting. Would it have been much more than General William Sherman's famous dictum that war is hell?

In the process of producing *The Syntopicon*, indexing their contents for relevance to the Great Ideas, I do not think we would have thought that either General Sherman's dictum or Picasso's painting was worth citing under any topic of the chapter on WAR AND PEACE. The banality of the statement would have led to its rejection.

Similarly, in *The Syntopicon* chapter on LOVE, we would not have cited as relevant the great Madonna and infant Jesus paintings for their relevance to the topic concerning maternal love or even to the topic concerning divine love. They say nothing of argumentative significance that other paintings discuss or dispute.

In addition, they make no contribution to the discussion of topics in the chapter on LOVE which can be associated with the contributions to the topics under the Great Ideas by such works of fiction in imaginative literature as the Electra tragedies or as William Shakespeare's sonnets.

If we return to musical compositions, Igor Stravinsky's *The Rite of Spring* has obvious relevance to the idea of love, and so does Claude Debussy's *Pelléas et Mélisande*, but that relevance is in no way comparable to the significance of Thomas Hardy's *Tess of the D'Urbervilles*, Henry Fielding's *Tom Jones*, or Leo Tolstoy's *Anna Karenina*.

Putting the question in another way, do paintings or pieces of music say anything about love that is not bet-

ter, more significantly and more disputatiously, already said about love in the great books?

### 4

The answer is, Yes, they do, even though the importance of what they add is not the same as the contribution of the great books to the Great Ideas.

Take the pieces of music and the paintings we have so far considered in relation to the Great Ideas of LOVE and WAR AND PEACE. There can be no question that they move us emotionally and sentimentally. Their direct, immediate, and powerful effect is upon our affections, not upon our minds.

The great poetry, the great plays and novels, move our minds—our conceptual intelligence, our intellects. We must first go through the process of interpreting them conceptually before they move us emotionally.

But the emotional effect of great pieces of music and of great paintings and statues is direct and immediate. They not only give us the aesthetic pleasure that occurs in our subjective experience of their beauty or aesthetic excellence. They also, and perhaps even more importantly, move us emotionally by their direct and powerful impact upon our imagination.

Psychologically, this is the familiar distinction between the cognitive content of our minds and its noncognitive affective content, including our bodily pains and pleasures and all of our other purely subjective feelings. Since these differ from individual to individ-

ual, we would not expect agreement or disagreement about them. They are not matters of objective truth, but rather of subjective taste.

The distinction between the sensitive faculties and the intellectual powers of the human mind, which has been so important in the preceding chapters, should be remembered here. All the nonverbal works of art fall into the sphere of the sensitive faculties, especially that of the imagination, even when it is illuminated by light drawn from the intellect. The language in which these arts express themselves is the language of nonverbal symbols. They are not means of communication, as I have defined it—that is, when two or more persons can engage in conversation about a common object they all have before their minds. Rather these works of art are means of self-expression, with each individual expressing his emotions, his sentiments, and his feelings.

In addition, it can be said that the great conversation about the Great Ideas, through the discussion that reading the great books engenders, has no parallel in the field of the nonverbal arts that exert their power on our sensitive, not intellectual, intelligence. The great painters and the great musicians do not engage in direct conversation with one another. They do not affirm or deny. They do not disagree and dispute.

The powerful emotional effect they have on us is subjective, differing from individual to individual as everything subjective does. But I daresay that the nonverbal arts directly affect more human beings and affect them more powerfully than do the great books. While

this may be true, it is also true that they do not instruct us concerning what is logically and factually true or false. They make no contribution to humankind's endless pursuit of truth.

Finally, this is not a matter of either/or. The verbal and nonverbal works of art are not in competition with one another. Though many people make the mistake of choosing to devote their attention, or even their lives, exclusively to one or another of the nonverbal arts rather than to the verbal arts, they are mistaken in their choice. The fully cultivated human being, not to say the best educated human being, is one who enriches his or her life, as well as his or her senses and their intellects, with a proper appreciation of what all the human arts, both those *with* and those *without* words, can do to round out a human life.

# CHAPTER 9

❊

# *The Argument Summarized*

In Chapter 1, I point out that until very modern times the word "art" was used correctly to name a human being's ability or skill to produce something or perform in some way. If that were not the correct use of the word, we would not be justified in calling human beings artists who are skillful in producing or performing.

In Chapter 2, I note that until modern times the term "fine art" had not been introduced and then was used exclusively for the visual arts. Even so, the word "art" was misused to name paintings and statues, when they should have been properly called "works of fine art," not "works of art." The clarifying history of the many misuses of the word "art" is also told at some length in Chapter 2.

In Chapter 3, readers are presented with significant distinctions made in the classification of the arts. The first of these distinctions involves a definition of the liberal arts. These are the arts of learning—all the skills

employed in learning, the arts of reading and writing, of speaking and of listening, and of calculating, estimating, and measuring.

These arts came to be called the seven liberal arts. Being an initiate in these arts created the degree called *bachelor of arts* in mediaeval universities. The teachers there were masters of these arts.

In Greek and Roman antiquity, the liberal arts had a different meaning. They were opposed, first, to the useful arts, and then also to the servile arts. As their name indicates, the servile arts were the skills or techniques possessed and used by slaves or artisans to produce the necessities and amenities of the household, the skills that today we call crafts, employed to produce useful artifacts or to perform useful services—all of which are good simply as means, never as ends.

The liberal arts, in this contrast with the servile and useful arts, were the skills possessed by free men to produce works of science, philosophy, and poetry; works of music and of sculpture, paintings on vases, and public buildings, especially temples. These are the arts that later came to be called the fine arts, when the word "fine" is understood to mean "finis" and to signify that the works produced by these arts were things to be enjoyed for their own sake, not to be used as means to further ends.

Another point of significance is contained in this distinction between the liberal and the servile arts. The servile arts produce works and performances that are

*inseparable* from matter. Servile artists transform the matter on which they work. Liberal artists, in contradistinction, produce their works by using words (which are verbal symbols) as well as nonverbal symbols such as musical notations. An important consequence of this point is that works of servile art can exist at only one time and place; they must have a unique location, whereas works of liberal arts are exempt from having a singular or unique location.

In the light of these distinctions and related points, the arts with which we are mainly concerned in this book—the arts of imaginative literature, musical composition, and the visual arts of painting and sculpture—are all fine arts in the modern sense of that term—arts of the beautiful—regardless of the ancient separation of the servile from the liberal arts.

In Chapter 5, readers learn some important distinctions in the philosophy of language, first and foremost being the distinction between signs and signals. The natural language of nonhuman animals is entirely a use of signals to express their emotions and sensitive desires. Signals occur in human language as well, but human language also contains designative signs by which things are named.

Readers should remember a second distinction made in Chapter 5—that between words used for the purpose of self-expression and words for the purpose of communication. Communication consists of two or more persons having a common object in mind and being

able to discuss it. Even if it looks as if people are communicating when they express themselves to each other, that is, strictly speaking, often not the case.

In this chapter, the word "symbol" is used in a restricted sense to signify nonverbal signs. Musical notations, for example, are symbols rather than signs because, functioning like signs, they are nonverbal.

This brings us to the main points in Chapter 5. The first is the distinction between formal and instrumental signs.

An instrumental sign is a perceptible but meaningless notation that has to be given or has to acquire meaning; it is a sign that can change its meaning or have many meanings.

In distinction from instrumental signs, formal signs are the meanings that meaningless notations acquire to become meaningful words. The intentional acts of the mind, by which the mind beholds its objects, are meanings; in short, the mind is the realm in which meanings exist. These meanings are conferred on meaningless notations to make them meaningful words.

In Chapter 5, readers are also apprised of the distinction between the sensitive faculties, which human beings share with other animals, and the intellectual powers that are uniquely human. Works of imaginative literature, as well as works of science, philosophy, theology, history, and biography, are produced in words and have the intellectual power that makes them relevant to the Great Ideas, for it is exclusively through words that human beings can communicate in discus-

sion, and can make assertions that lead them to dispute with one another about some common objects of thought.

Works of fine art are produced in the sphere of the sensitive faculties, especially the imagination, which is still a sensitive power even when it is illuminated by light from the intellect. Understanding this point involves understanding the radical distinction between perceptual and conceptual thought, the former a way of thinking and knowing that the higher mammals as well as human beings have; the latter being exclusively human.

Because of the troublesome ambiguity in the use of the word "idea" (both for the contents of the mind and for its objects), Chapter 5 introduces the phrase "cognitive mental content" to name the contents of the mind by which we know and understand. There is, of course, noncognitive mental content—our bodily feelings, our pains and pleasures, our emotions and sentiments. We also use words to express such noncognitive mental content.

In this connection, it is important for readers to remember the fact that we are directly aware of mental content that is noncognitive; but of the cognitive mental content, we cannot be aware. We cannot apprehend it, for to do so would violate its function of presenting objects to the mind. In short, cognitive mental content is always that *by which (id quo)* we apprehend the objects of the mind, either sensible or intelligible objects, never *that which (id quod)* we apprehend; and it

is such inexperienceable cognitive mental content that enables us to know and understand the objects of perceptual and conceptual thought.

What has just been said does not apply to the symbolic, or nonverbal, languages of music and the visual arts. Such nonverbal symbols do not function as that whereby we know and understand. Instead, they operate to present us with sensible objects that we can experience and enjoy in the sphere of perceptual thought, especially in the sphere of imagination. These sensible objects may have some resemblance to things we perceive in the realm of natural phenomena, or they have no resemblance to natural phenomena, as is the case with twentieth-century nonpictorial paintings.

Chapter 6 clarifies the word "ideas" by pointing out that it is used in the Platonic sense of intelligible objects, while correcting Plato's error of asserting that ideas as intelligible objects exist immutably in the realm of being, unlike the objects of perceptual thought that have reality in the ever-changing, sensible realm of becoming.

Chapter 6 also elaborates on the distinction between perceptual and conceptual thought. It explains that when our cognitive mental content is sensitive rather than intellectual, it is also not apprehensible. But this point does not apply to sensitive mental content that is noncognitive. In this case the mental content that is noncognitive consists of experienceable perceptual or imaginable objects—objects that we can experience and enjoy, differently for different human beings.

Finally, Chapter 6 calls our attention to the cognitive acts of the human mind. In the sphere of perceptual thought, these are acts of apprehension, whereas in the sphere of conceptual thought they are, in addition to acts of apprehension, acts of judgment and acts involved in the process of reasoning.

Chapter 7, readers will remember, tells us what the Great Ideas are and are not. They are not cognitive mental content in any human mind. They are not Platonic ideas, though they are intelligible objects of conceptual thought, and though as such they are not like any other intelligible objects of conceptual thought by reason of the fact that they have an elaborate interior structure.

The phrase "great ideas," like the phrase "great books," did not come into existence until the fourth decade of this century. Previous to that no one can find a reference to great books in scholarly literature. They were called classics.

The "Great Ideas" are an invention called for by having to find a solution to the problem of how to construct an "idea index" to the thought to be found in the great authors and their great books.

Since an ordinary index is always an index to the thought found in a single book or in books by a single author, it was impossible to construct an "idea index" for the intellectual content of a set of great books comprising seventy-four authors and 443 works in the twenty-five centuries of Western civilization, involving many different languages and different cultural epochs.

Chapter 7 tells the story of the invention of *The Syn-topicon* and of the process by which the 102 Great Ideas were chosen as the headings under which thousands of topics were subsumed. This led to the production of 102 Outlines of Topics, one for each of the 102 Great Ideas.

The story told in Chapter 7 of why this had to be done, and how it was done, includes the solution to the difficult problem of citing references to the great authors and books of imaginative literature—narrative fiction, plays, novels, and stories. If this problem of citing references to the topics under the Great Ideas to works of fine art in the sphere of imaginative liter-ature could be solved, why could not the same be done for the other works of fine art, such as musical com-positions and works of visual art? That question was asked, but not answered, in Chapter 7. It was answered in Chapter 8.

Chapter 8 explains the answer in terms of the dif-ference between (a) fine arts that use our everyday language, consisting of meaningful words and sentences that function in the sphere of conceptual thought, and (b) fine arts that use nonverbal symbols and operate in the sphere of perceptual thought, especially in the sphere of the imagination.

This is the negative side of the answer to the question why such fine arts as music and painting do not produce works that have referential significance to topics sub-sumed by the Great Ideas.

Chapter 8 then takes up the positive side—the great

contribution made by such works of art, their great human value even if they do not contribute to the discussion of the Great Ideas. Since such great works of fine art have intrinsic aesthetic excellence, we enjoy them for their own sake—for their beauty, which is the pleasure we enjoy in apprehending them—the subjective pleasure we enjoy in their presence. Since this is the subjective aspect of beauty—beauty in the eye of the beholder—it will differ from person to person.

It may not even be experienced by some individuals, while occurring to a high degree for others. When it happens, that aesthetic pleasure is of great human importance in being a higher pleasure than the lower and more fleshly pleasures. It is right that individuals seek such aesthetic pleasure.

Chapter 8 adds an even more important point about the great human value inherent in the nonverbal fine arts. It tells us that they act directly and powerfully on our emotions and sentiments. They move us directly in the sense that they do not need the intermediation of thought.

When works of imaginative literature move us emotionally, they do so through the intellect. Only after we interpret them does our intellectual understanding of their message evoke an emotional response from us. That response, being subjective, will differ from individual to individual. It may not occur in some individuals, and it may occur to different degrees in different individuals.

It is not surprising, therefore, that many more in-

dividuals in any human population will be directly affected by music and painting than will be emotionally affected by works of imaginative literature. The popularity of concert performances and visits to museums is much greater than the popularity of libraries and the sale of works of literature in bookstores.

Ideally, the cultivation of human beings should consist of cherishing the human values to be found in music and paintings, as well as the value to be found in intellectual and imaginative literature.

The foregoing summary of the argument contained in this book suggests that readers should now be prepared to answer the following three questions:

(1) Can paintings and musical compositions be cited under one or another topic in *The Syntopicon* as expressing a view differing from or contrary to the opinions or views expressed in the passages cited from the great books?

(2) Can two paintings or two musical compositions be cited under one or another topic in *The Syntopicon* as expressing differing or contrary views or opinions that run parallel to the differing or contrary views or opinions in the passages cited from the great books?

(3) Can paintings or musical compositions be cited under one or another topic as being concrete exemplifications of the theme described in this or that topic, in the same way that narrative passages in

imaginative literature or even whole books of this kind can be cited as relevant to this or that topic?

If the answers to the first two questions are negative, then those who give negative answers should conclude that paintings and musical compositions, whatever else their positive value, do not contribute to the discussion of the Great Ideas and, therefore, should not be made the subject of Socratically conducted seminar discussions. If the answers to these first two questions are positive, readers should reread the earlier chapters in this book.

If the answer to the third question is positive, then individuals who give this answer should be prepared to name the musical compositions and paintings that justify a positive answer to the third question or to ask experts in the fields of music and painting to do so.

# EPILOGUE

# *Art for Art's Sake*

This book needs an epilogue for one purpose only. Not to correct or alter the negative and positive conclusions about the fine arts of music and painting that we reached in its concluding chapter, but to state a point of view with which I am sympathetic, but which, when taken to the extreme, I must reject.

It is the negative conclusion that might lead some readers to think that I embrace the position of those purists about the fine arts who say "art for art's sake." They, too, would say that the fine arts of painting and music—and they often include poetry and imaginative fiction—have little or no relevance to the Great Ideas.

But they go further than that (and this is their extremism) when they say that the fine arts should serve no purpose whatsoever. They should just be true to themselves and glory in their own aesthetic excellence.*

*They use the word "art" but by that they mean only the fine arts.

When, for example, Oscar Wilde declares that all art is quite useless, I take him to mean more than that the fine arts are to be enjoyed for their beauty, not used as a means to some end. He is declaring that the fine arts should serve no purpose whatsoever. He would dissent from my praise of the fine arts for the emotional effect they have upon their audience. He would dismiss their appeal and the popularity they achieve because of their power in moving us through our feelings. He would be quite content with an appreciation of the fine arts purely for the aesthetic pleasure they give us.

In the chapter on the School of Giorgione, in his book on *Studies in the History of the Renaissance* (1873), Walter Pater makes the astounding statement that "all art constantly aspires toward the condition of music." That statement is astounding not because it says "all art" when he means by art only the visual arts, but because when he refers to the condition of music, he clearly has in mind "pure music" with no title except an *opus* number, and totally devoid of any program and not deriving any meaning from association with literature.

One might even conclude from this statement that Pater would think that the art of painting achieved the condition of pure music in the nonpictorial paintings that first emerged in the twentieth century. That would be "pure painting" in his estimation. It would be like "pure music"—both exempt from the intrusion of literary illusions or embellishments. It is this extreme purism that I reject.

In a statement he made at the Oxford Poetry Club, T. S. Eliot appears to adopt the position of extreme purism even in the sphere of imaginative literature, where, it seems to me, it is most out of place. When an undergraduate asked him what he meant in a line from *Ash-Wednesday*—"Lady, three white leopards sat under a juniper-tree"—Eliot answered, "I mean, 'Lady, three white leopards sat under a juniper-tree.'"

This appears to rule out any effort at interpreting the meaning of the poet's words. It seems to have some affinity with the nihilistic deconstructionism of Jacques Derrida. If we dismiss such negativism and purism as unjustifiable, we might still be able to disassociate Eliot's position from the incoherently self-contradictory position of the deconstructionist Derrida. In antiquity, in his *Ars Poetica*, Horace writes that poetry serves two purposes: instruction and delight. T. S. Eliot may be ruling out instruction and settling for delight.

Even so, I am finding myself still disagreeing with Eliot. Readers will remember that I pointed out how we were able to cite references to passages in poetry and imaginative fiction as relevant to topics subsumed under the Great Ideas. If that was done correctly, as I think it was, then great poetry and imaginative fiction accomplish both purposes. They do more than delight us and give us pleasure; they certainly instruct in a manner that is comparable to the instruction we receive from works of science, philosophy, theology, history, and biography.

# INDEX